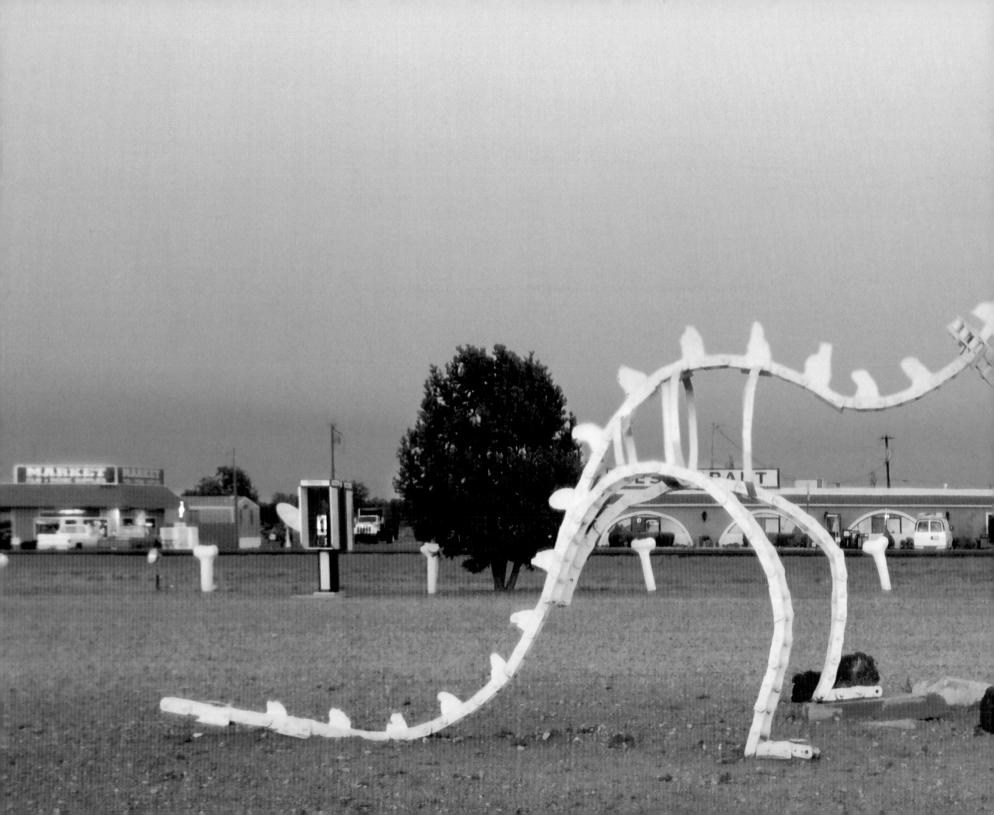

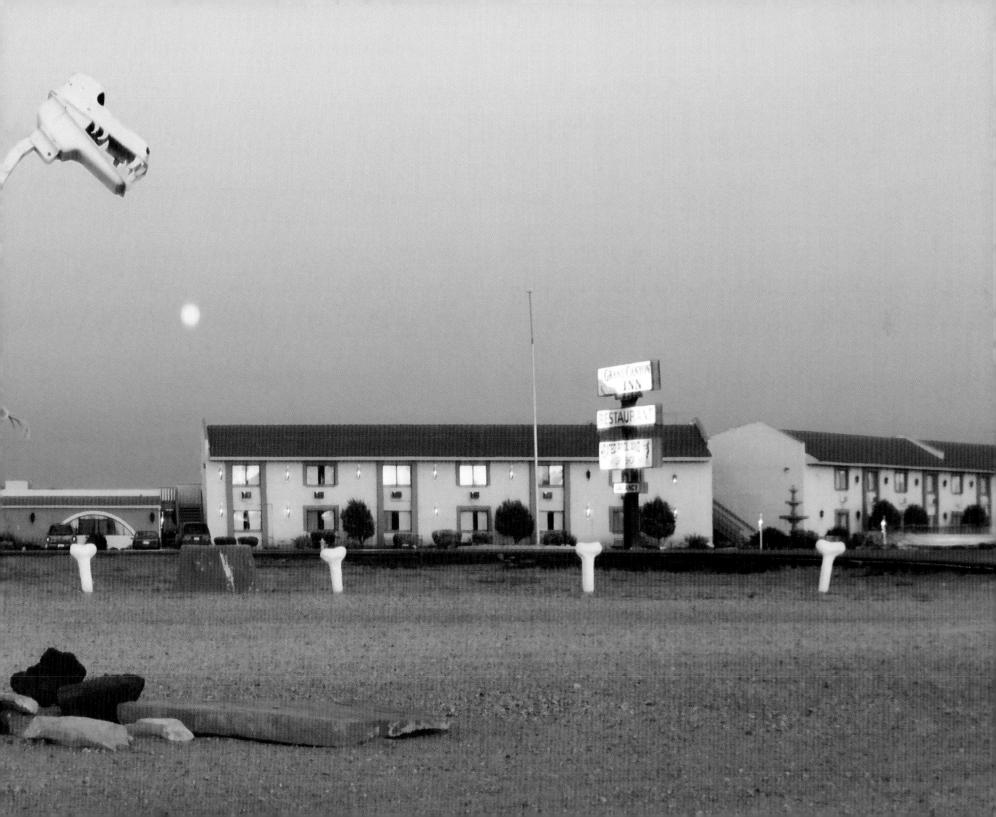

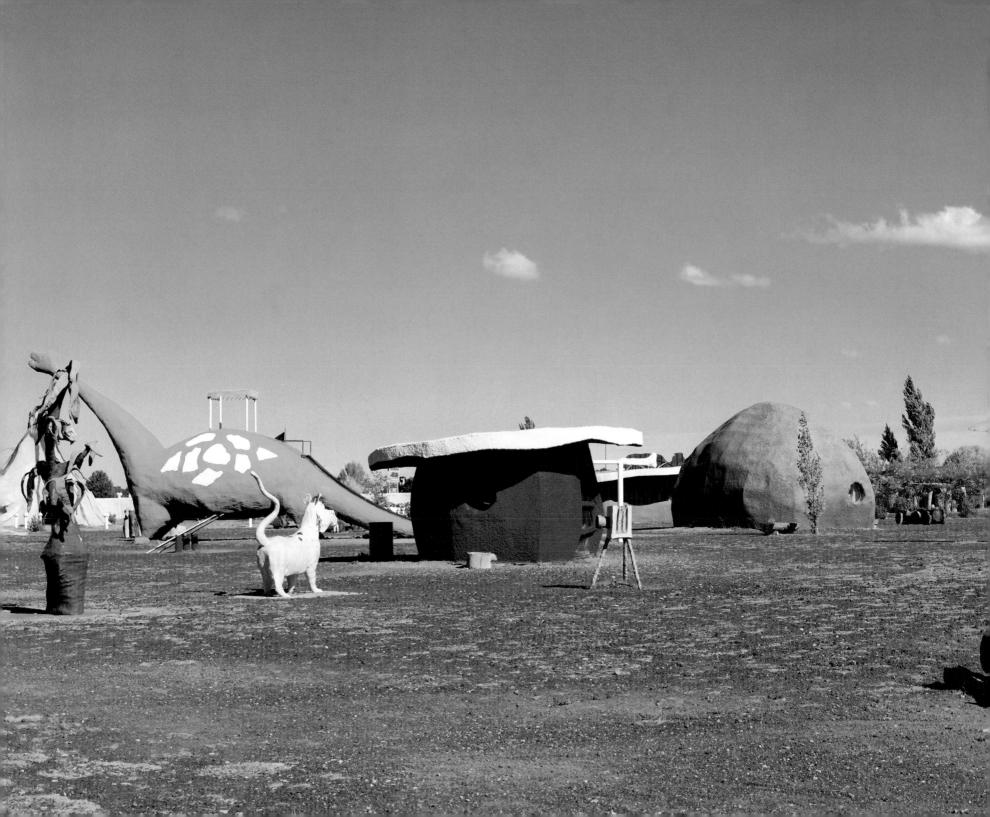

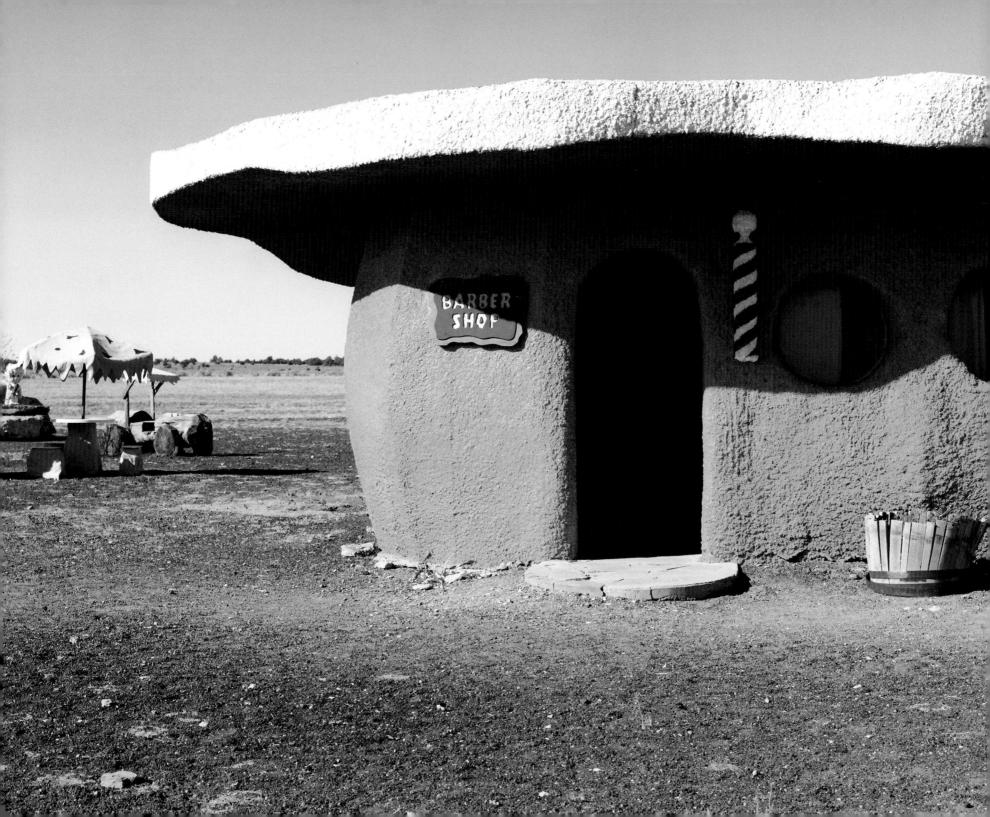

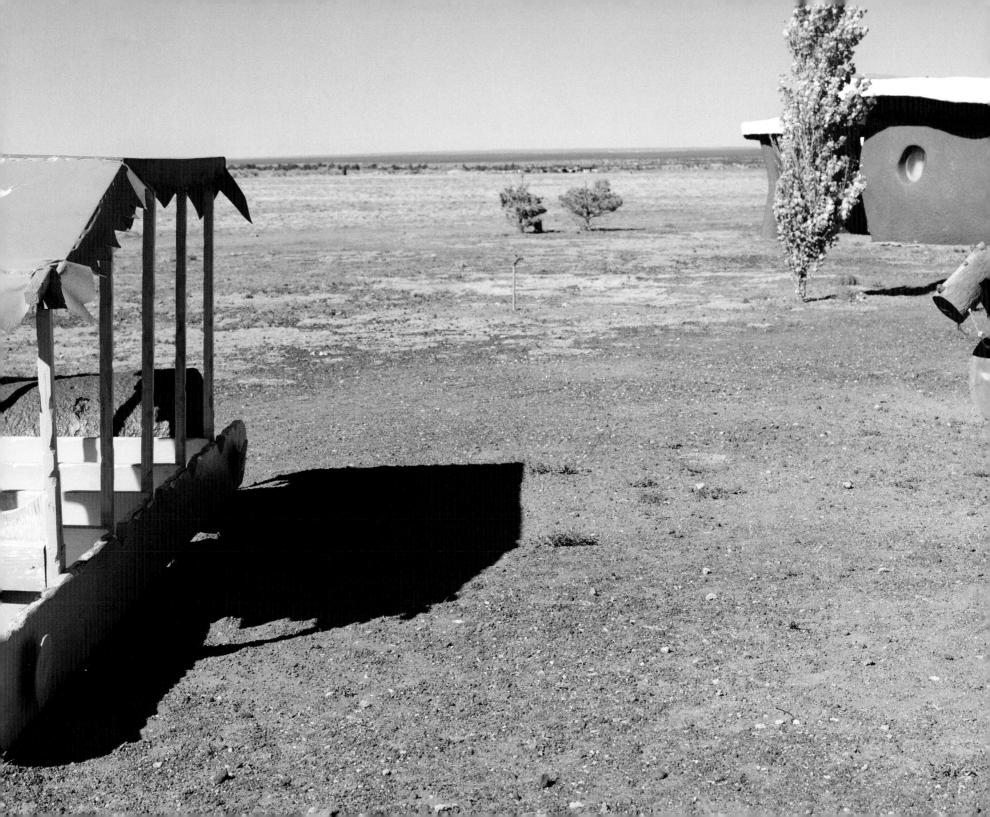

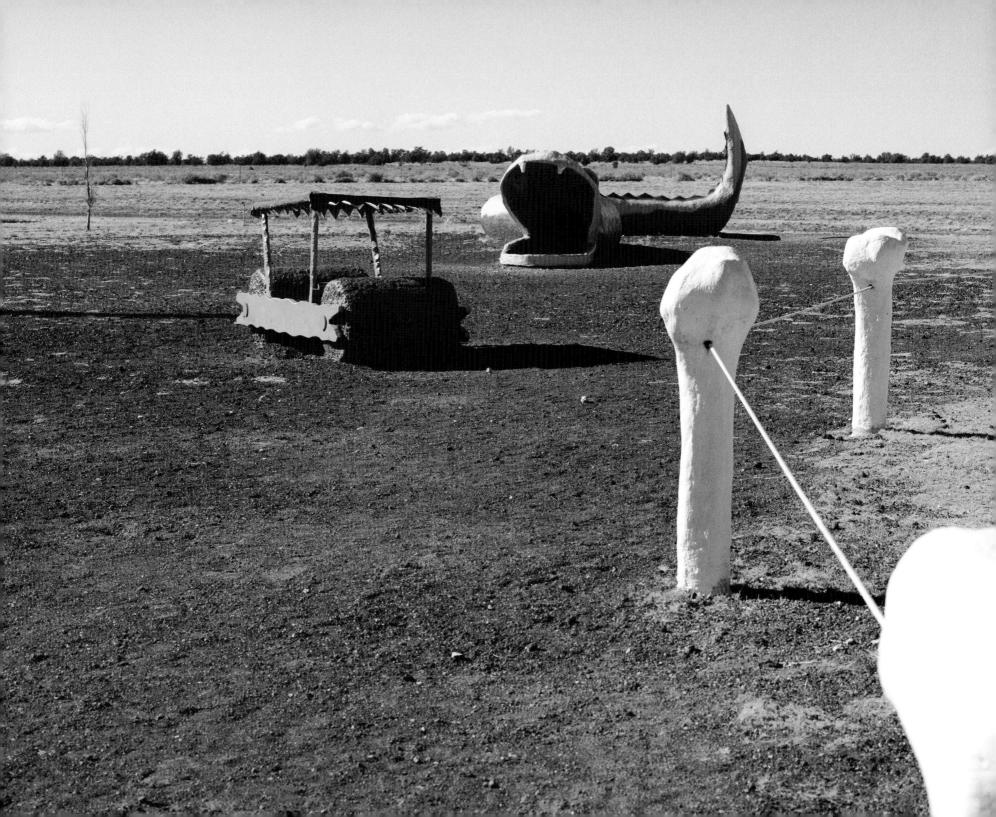

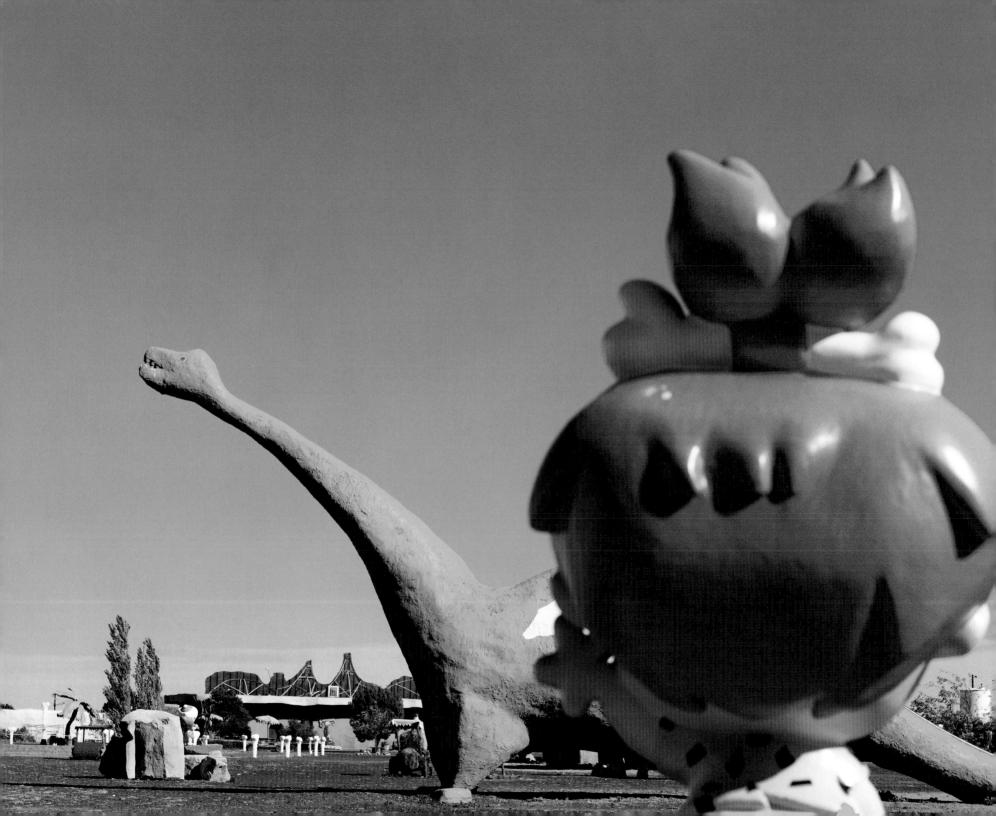

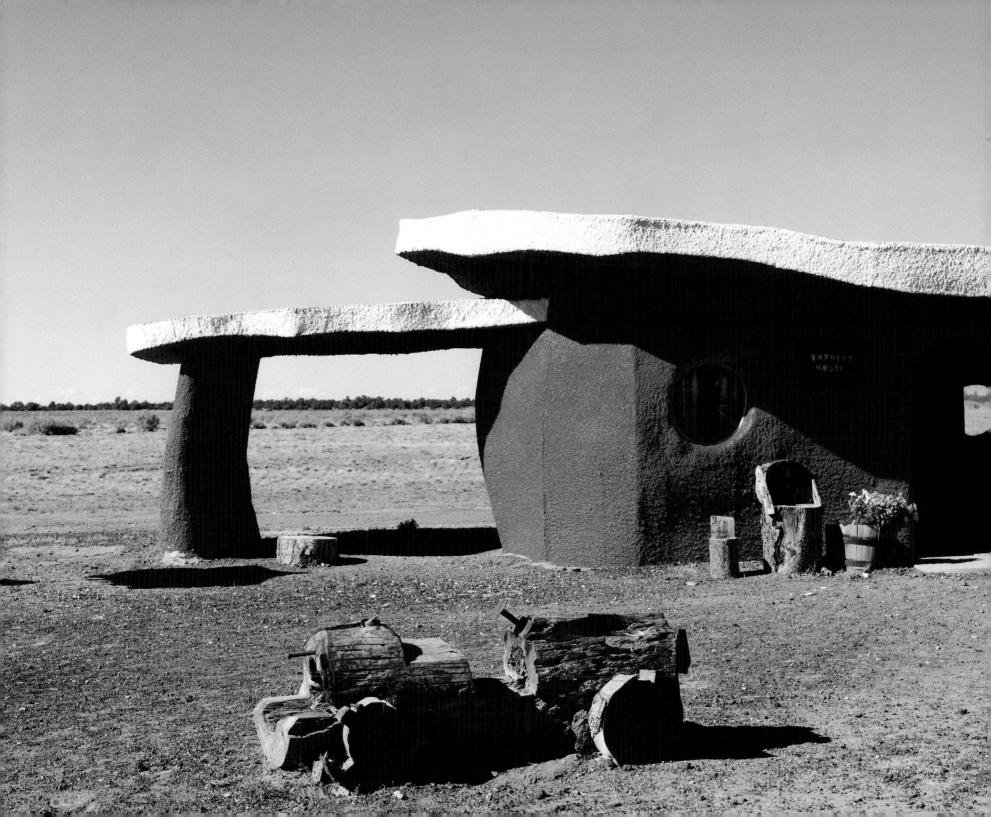

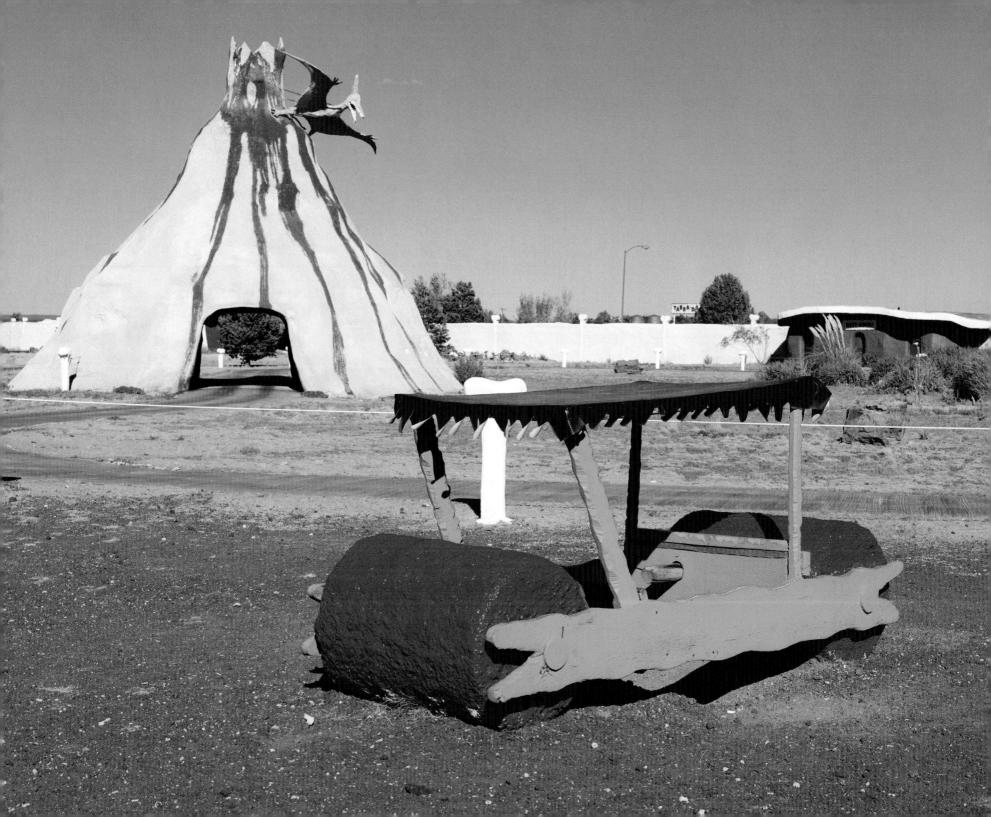

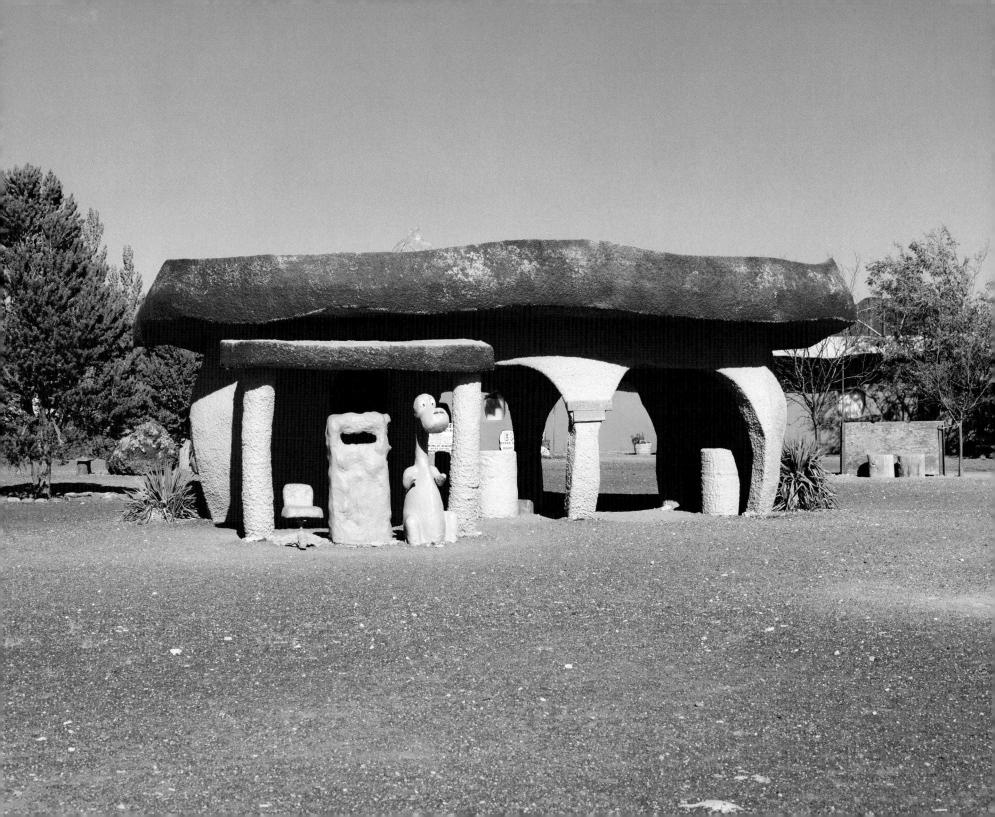

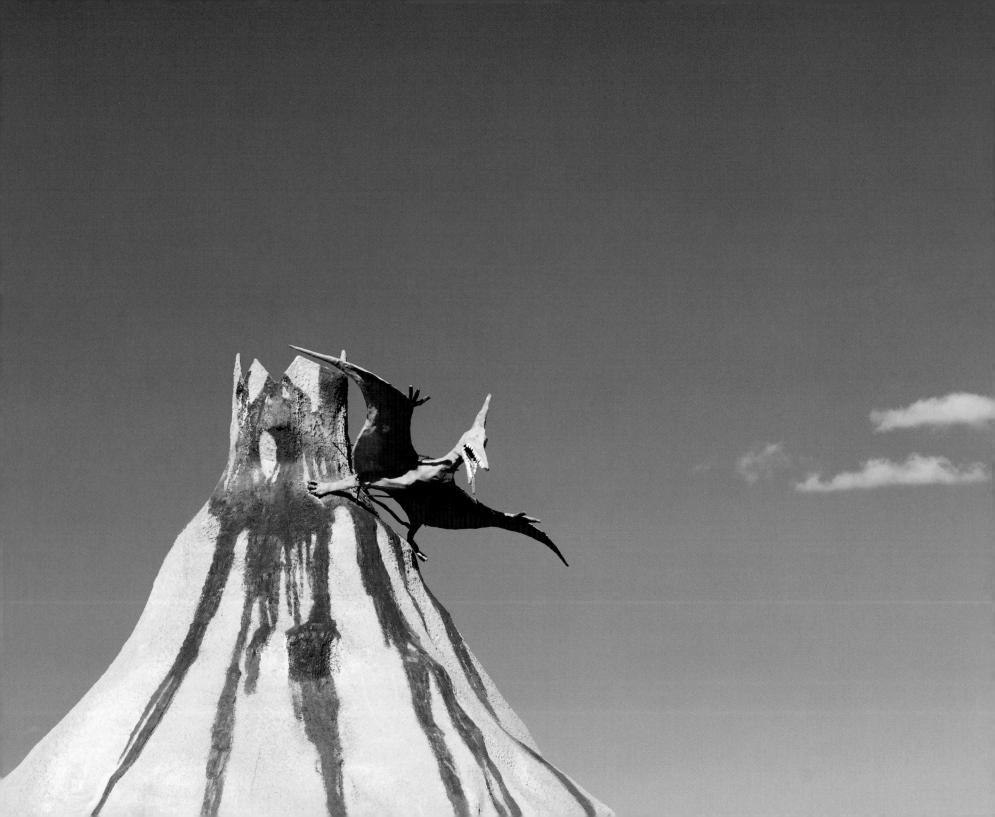

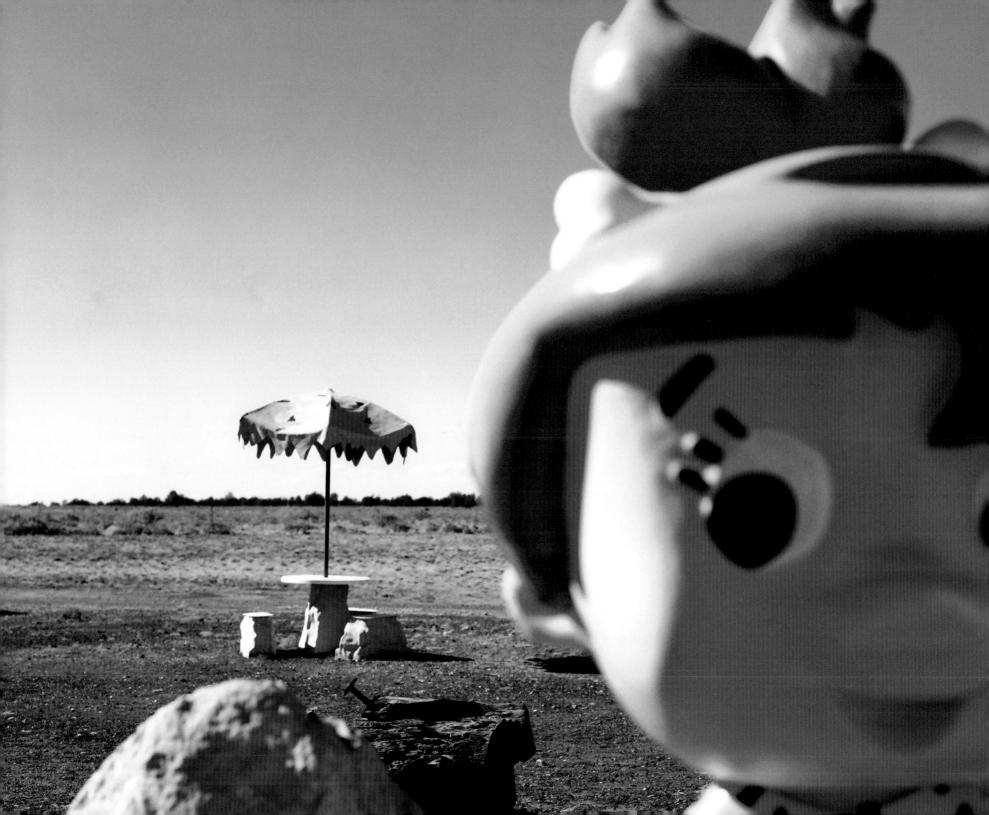

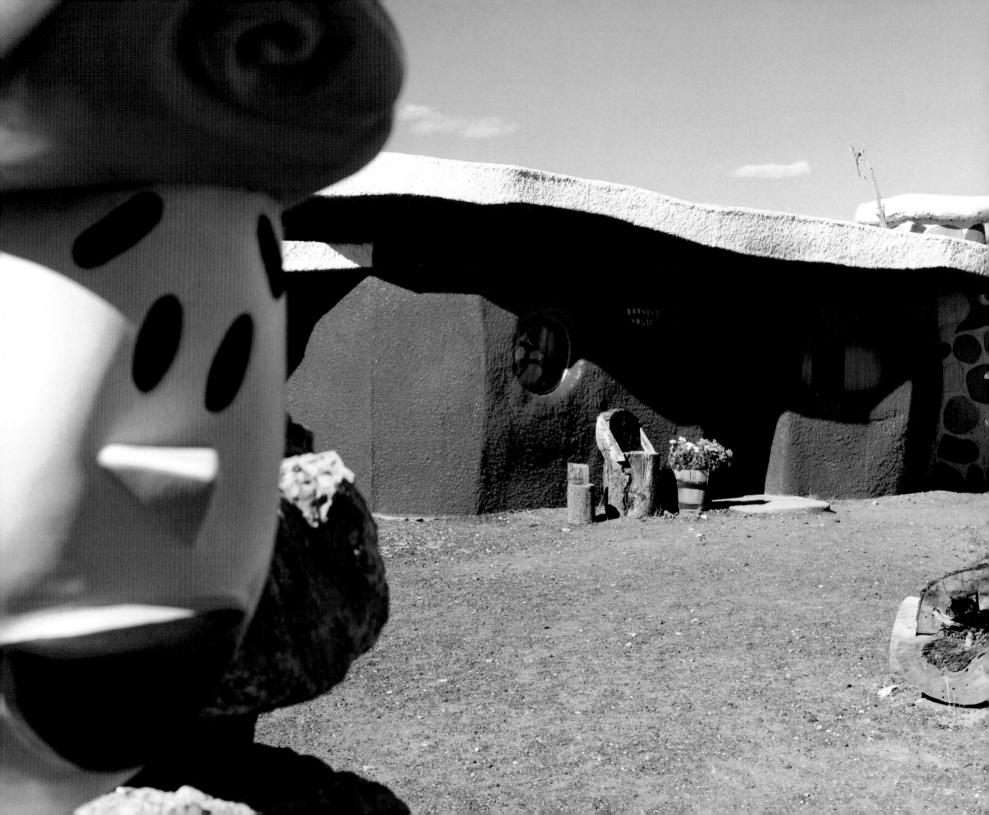

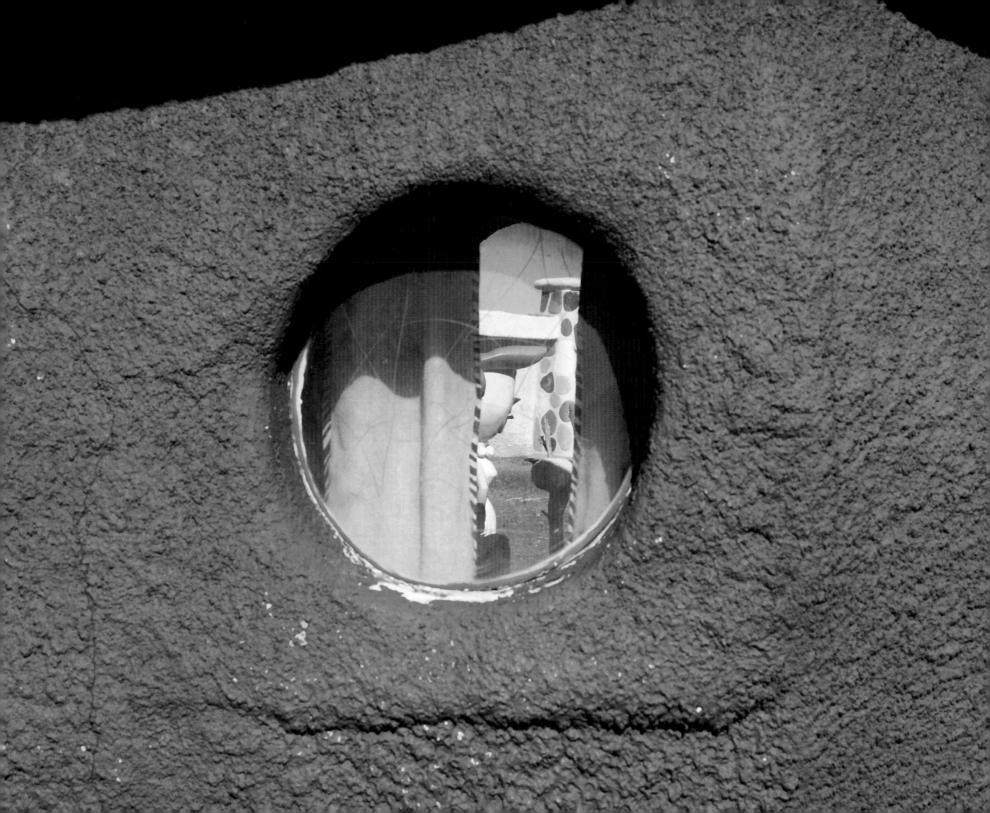

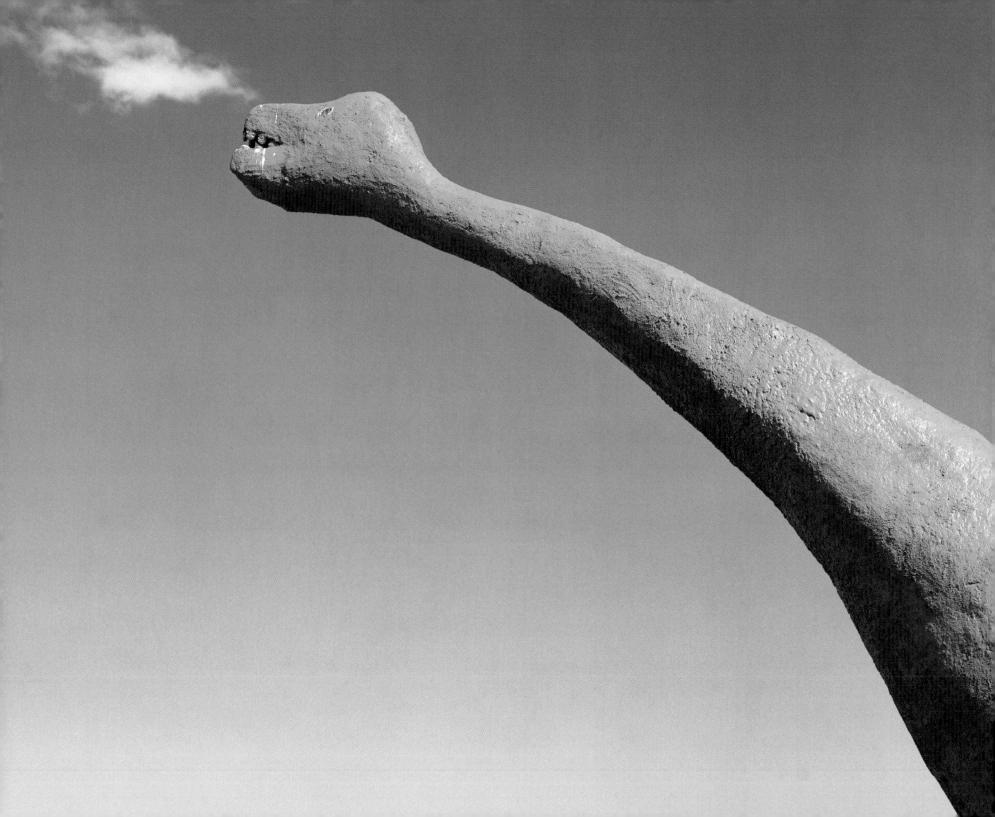

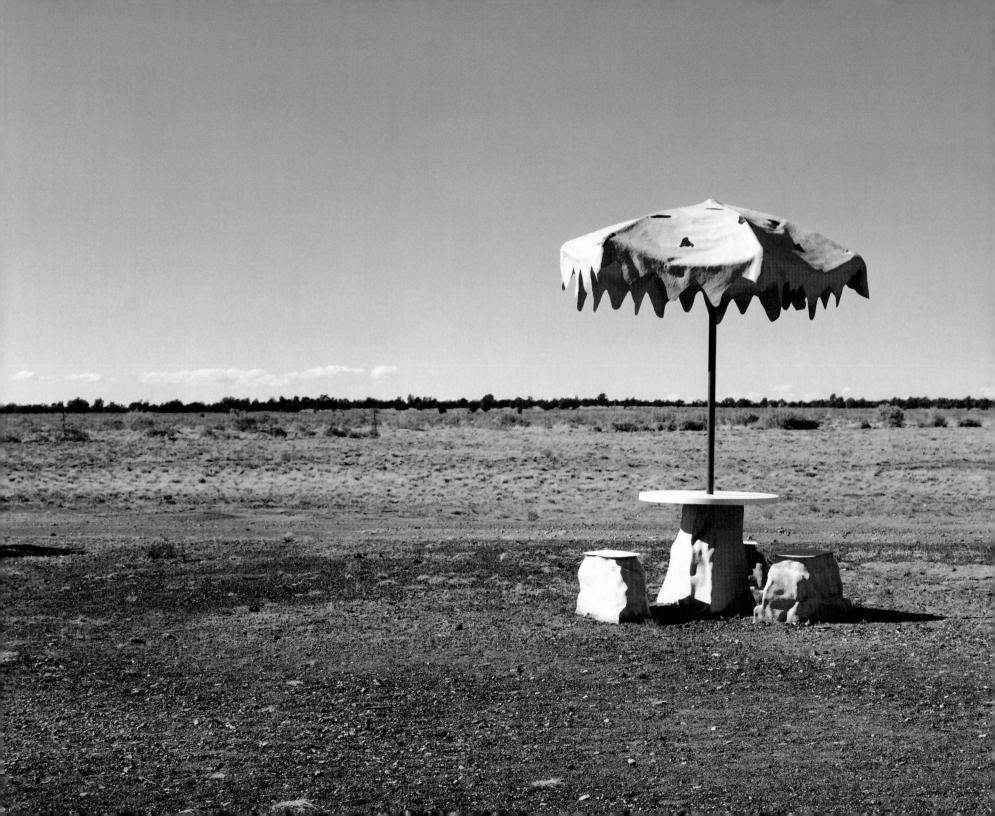

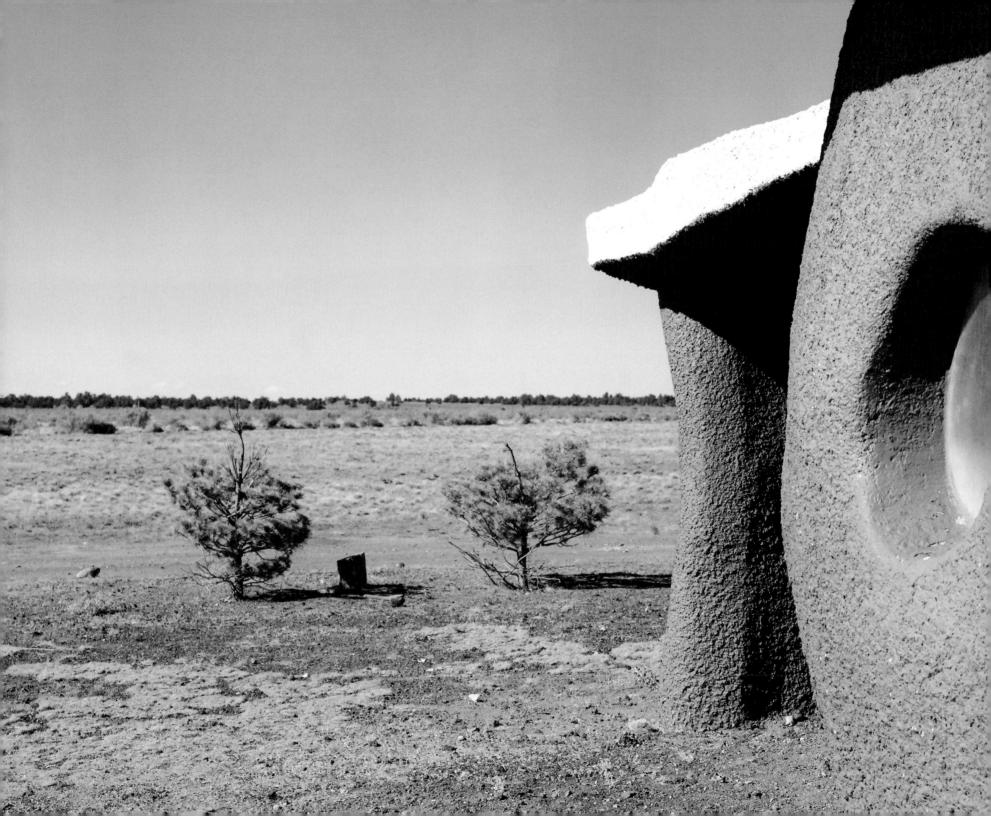

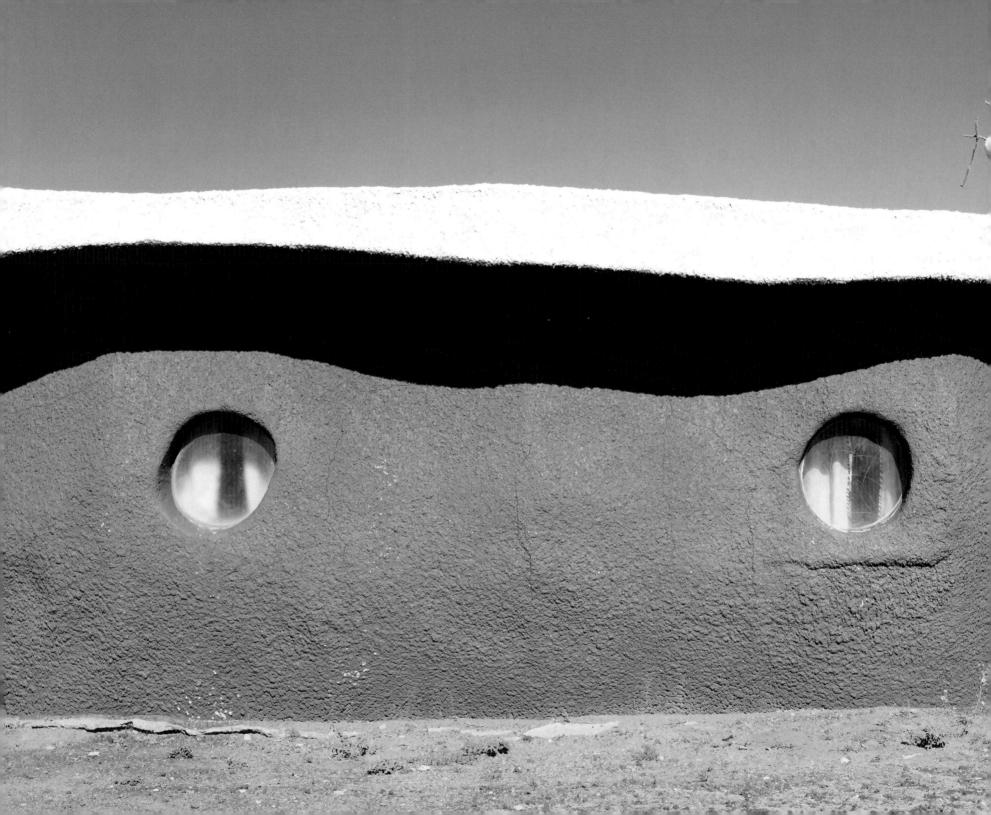

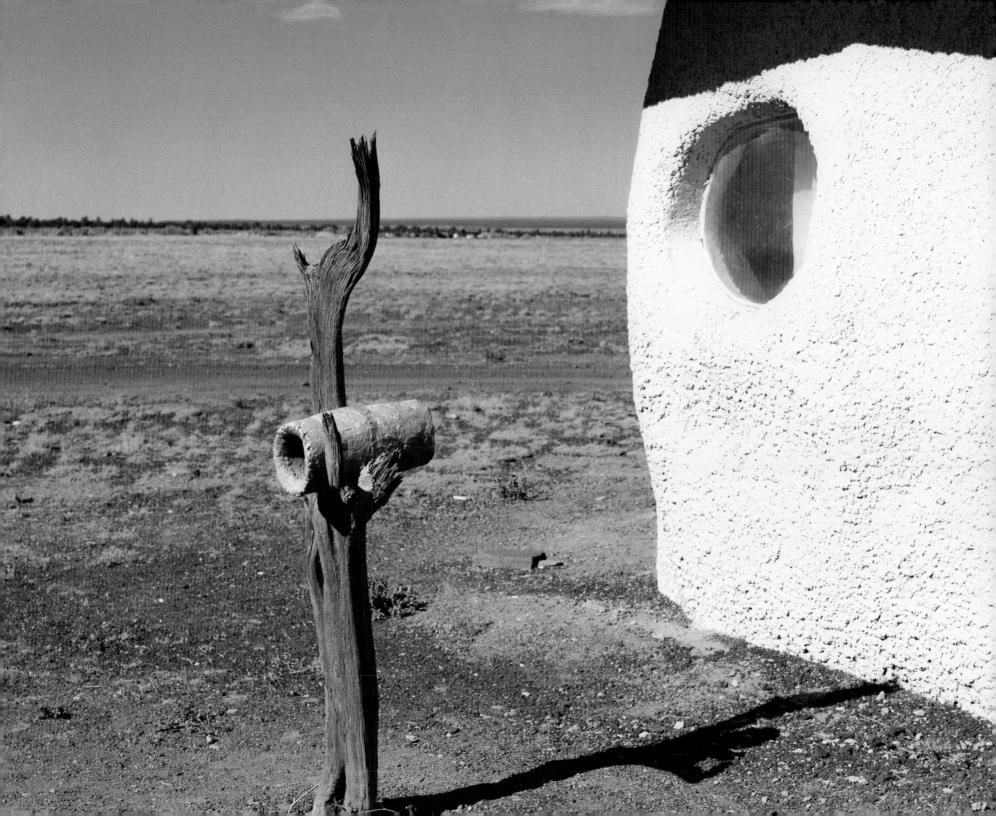

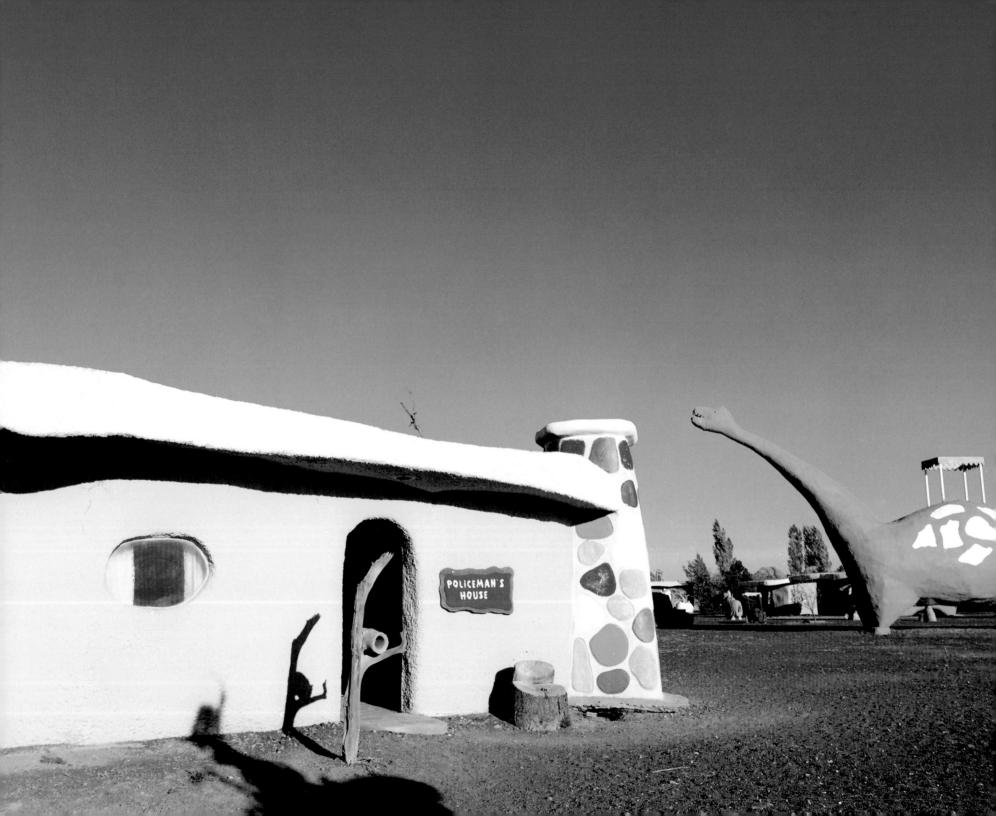

POLICEMAN'S HOUSE

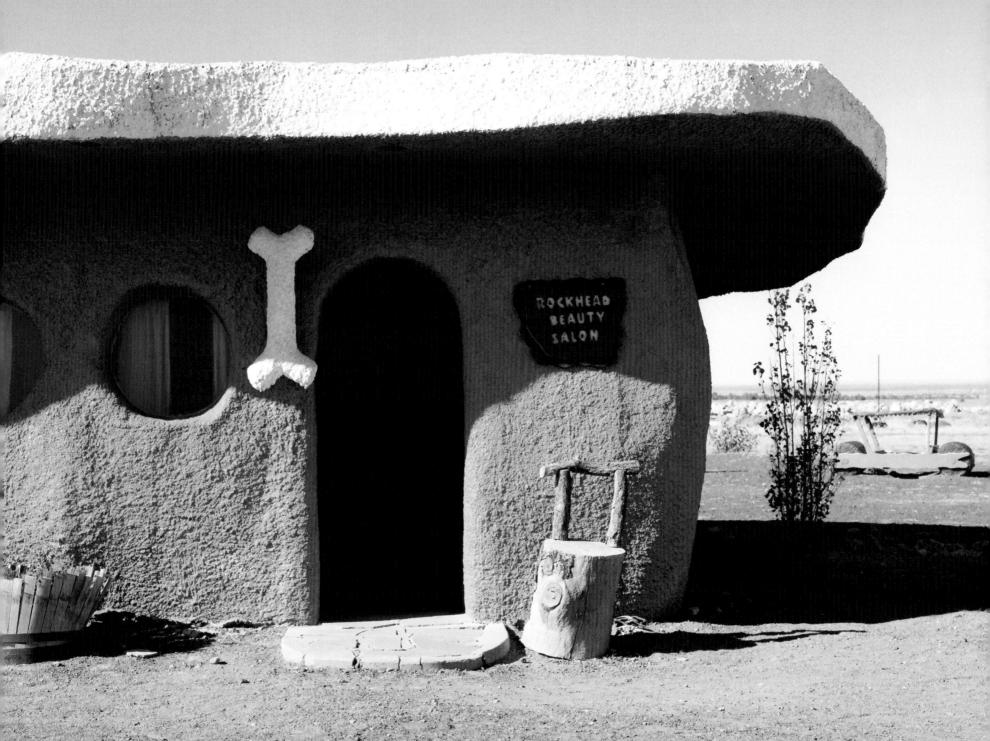

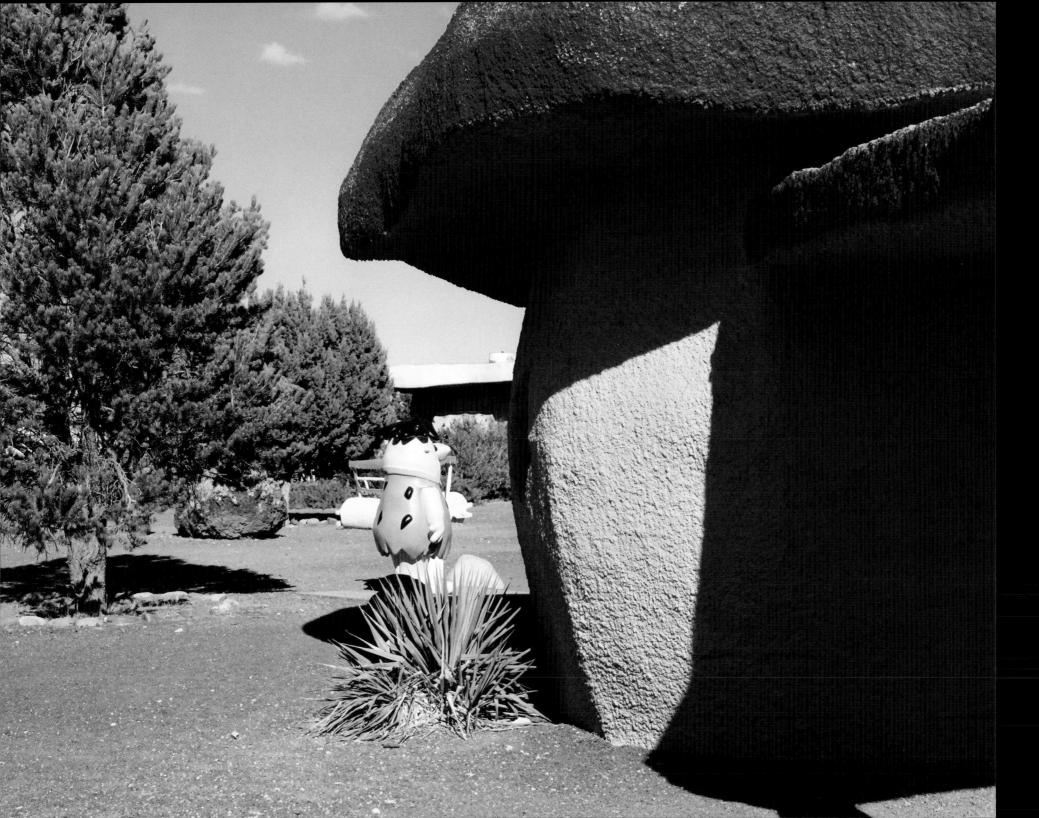

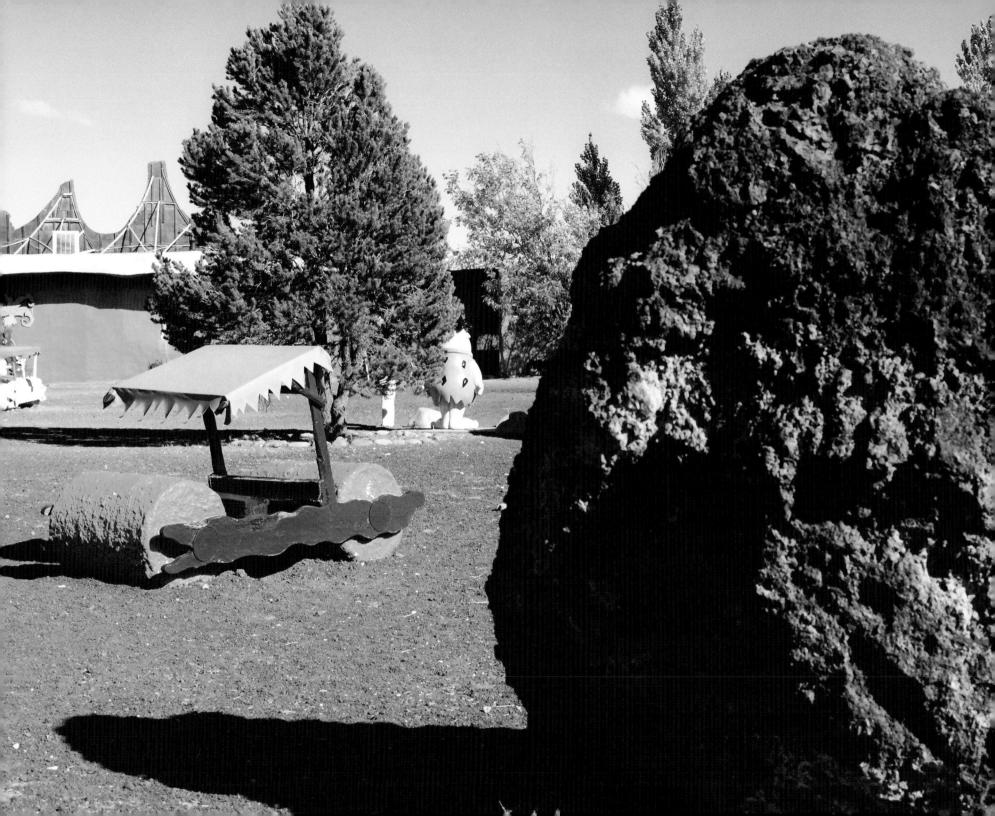

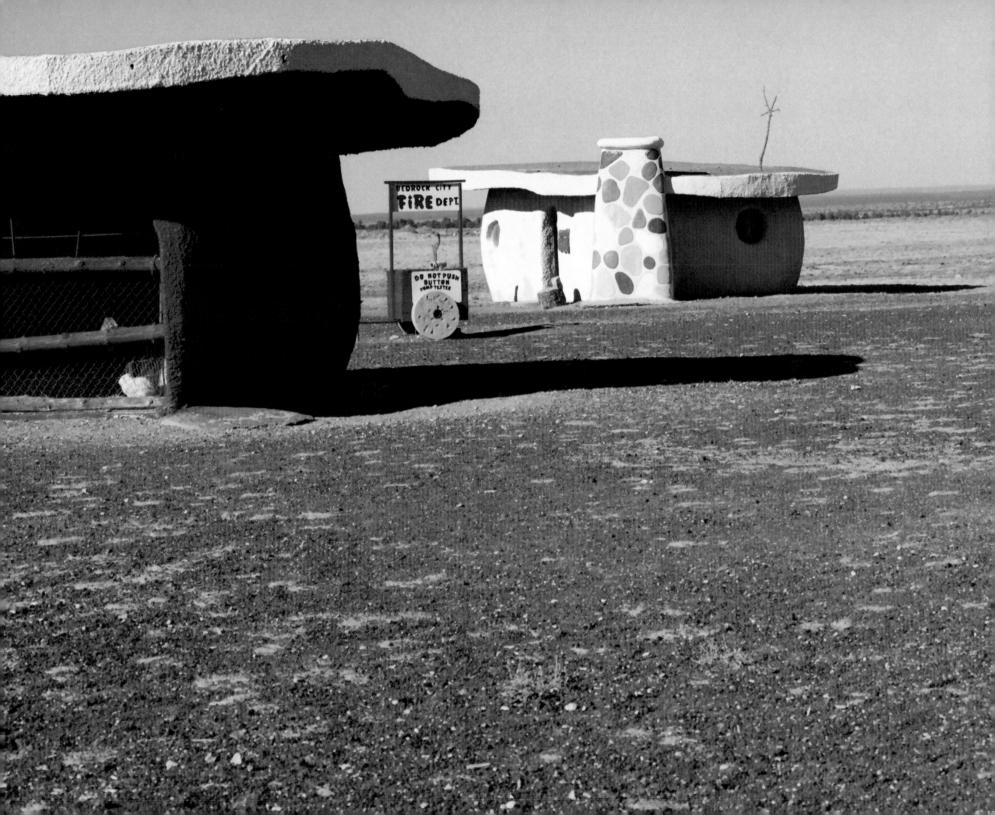

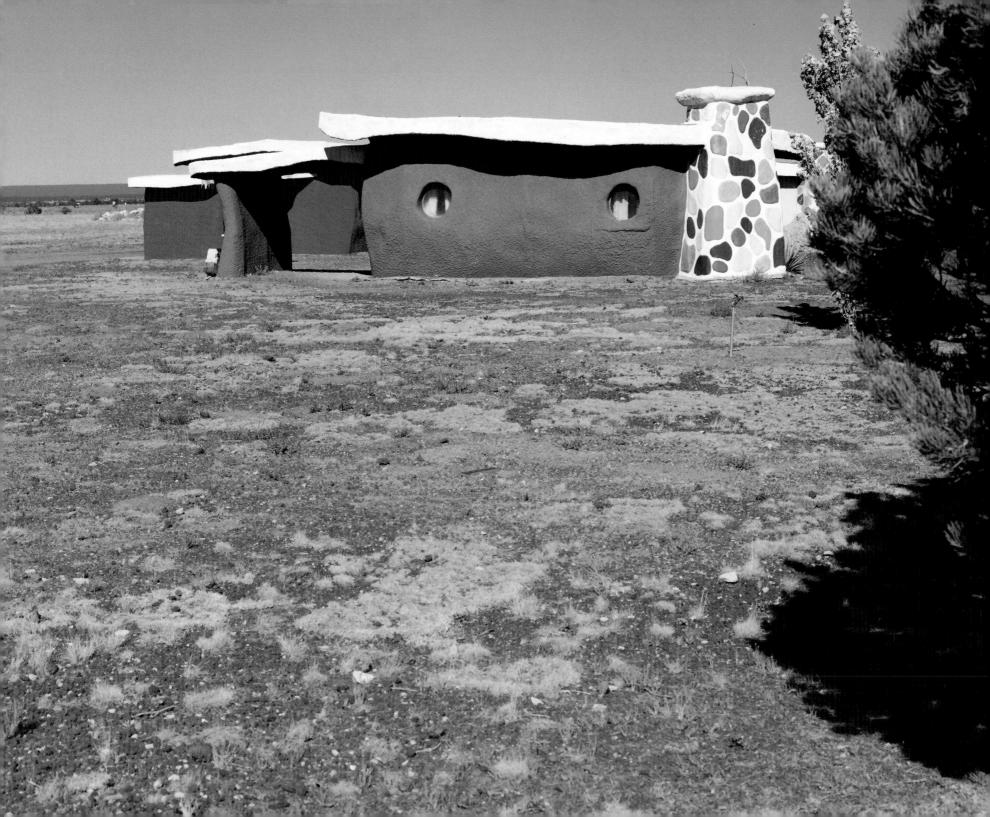

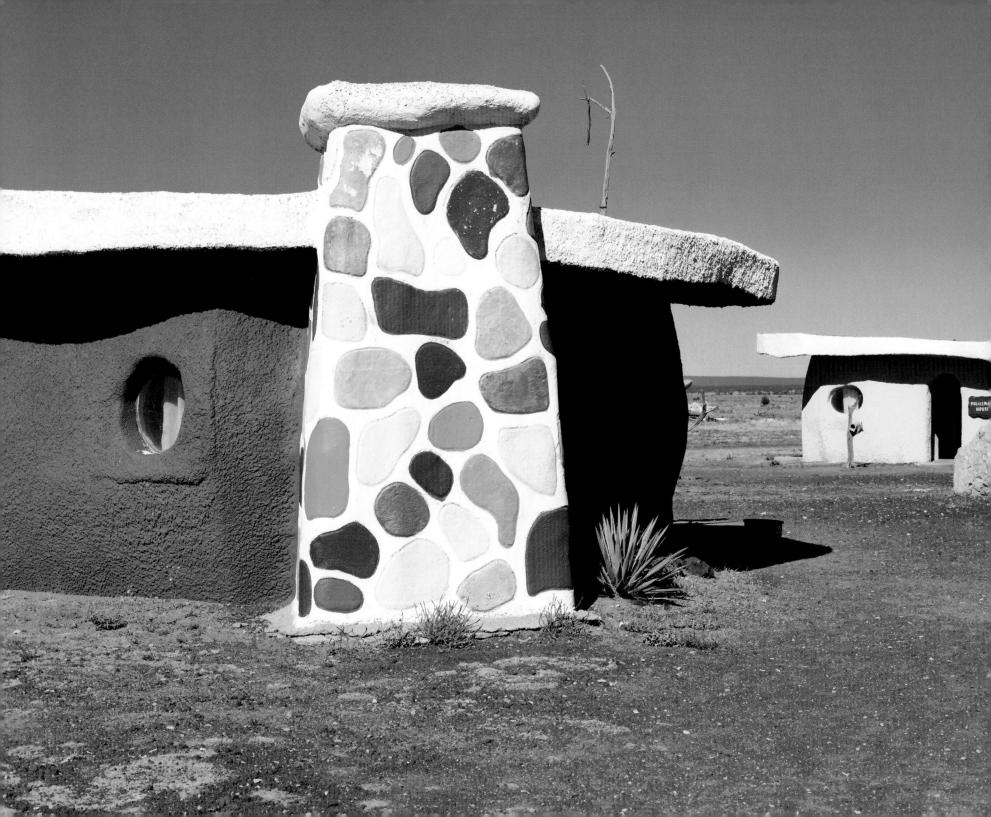

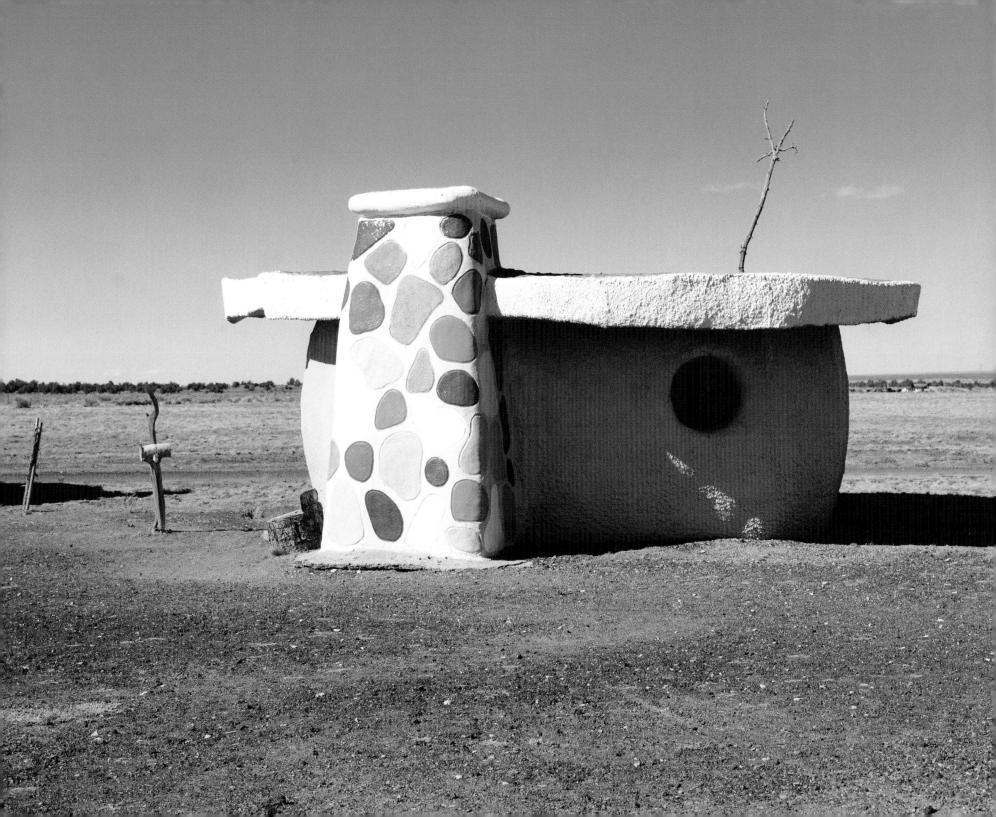

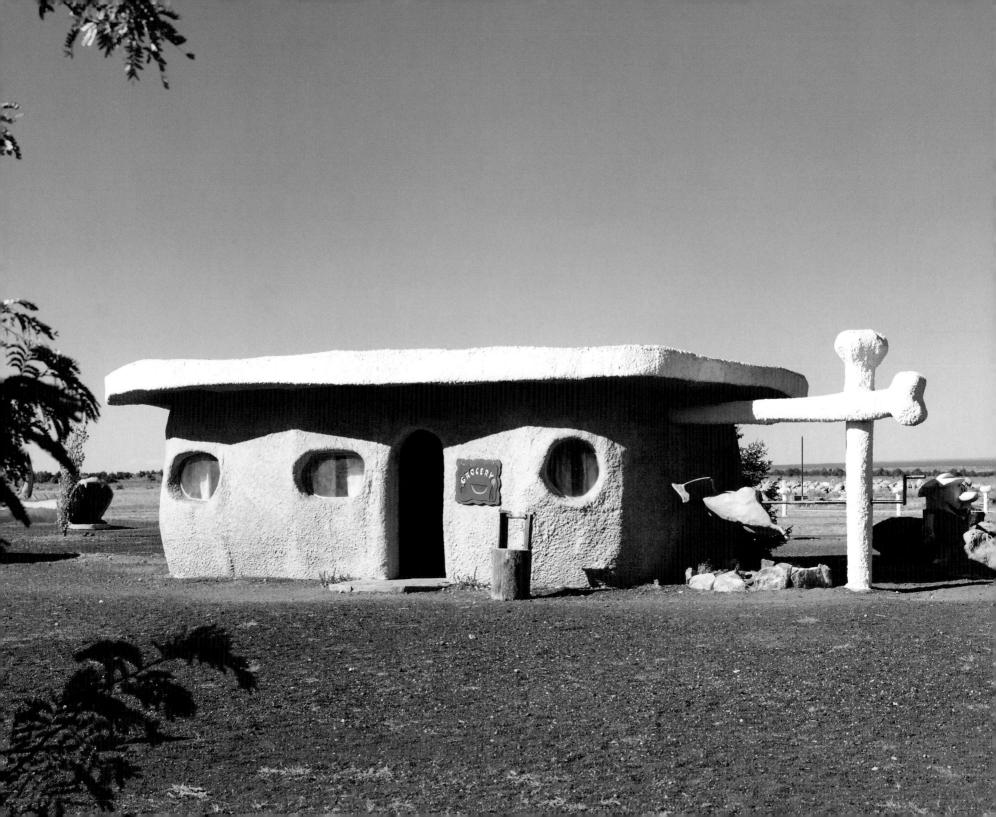

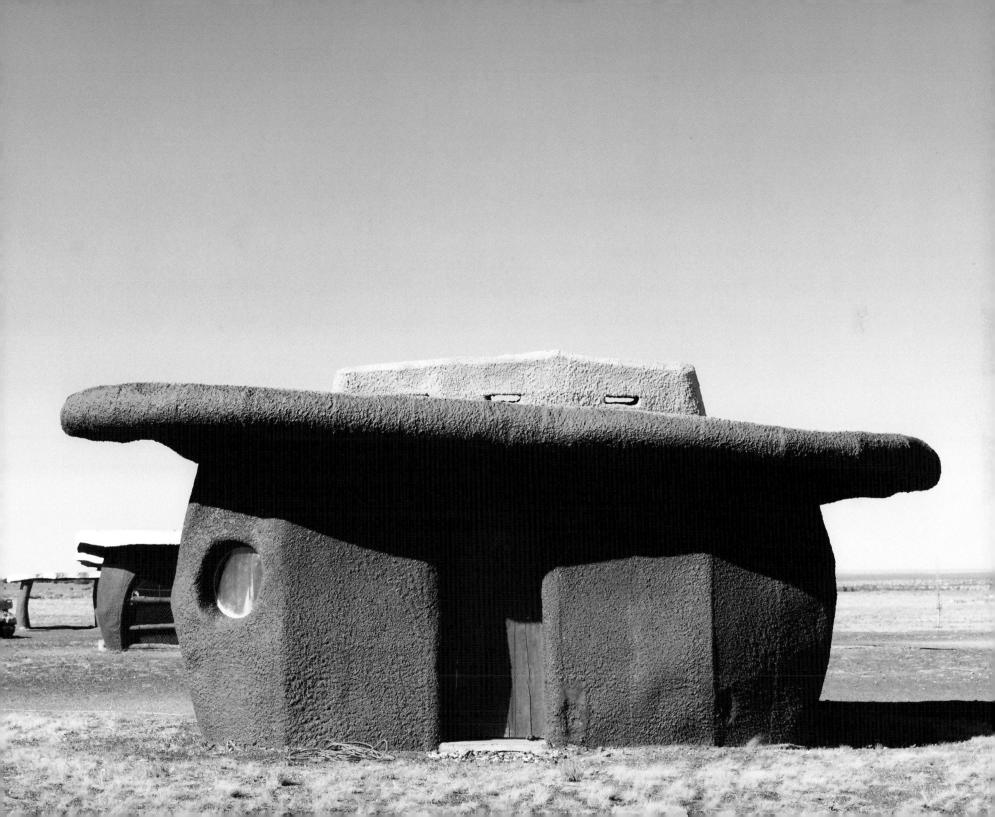

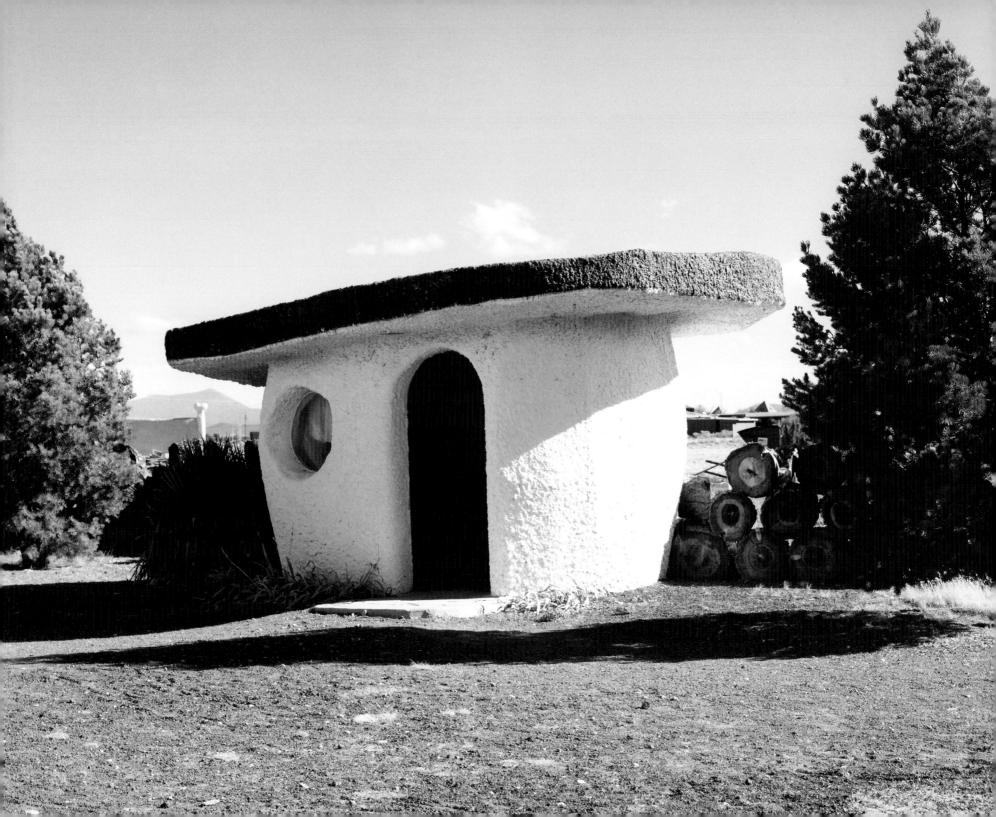

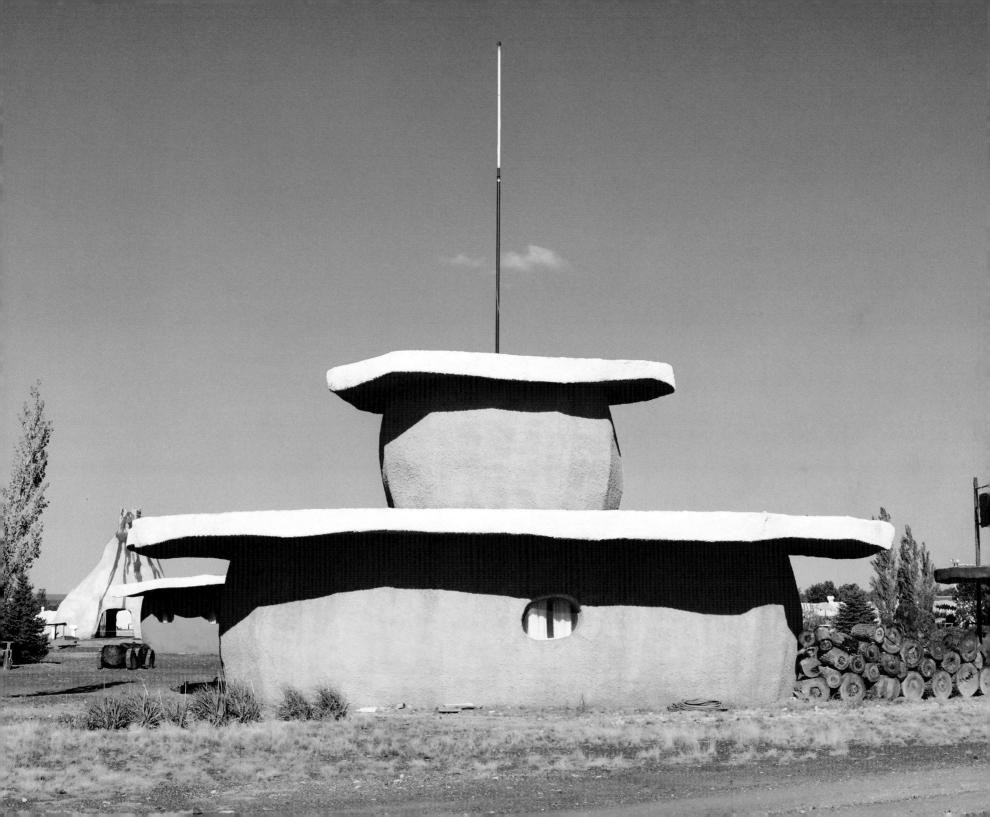

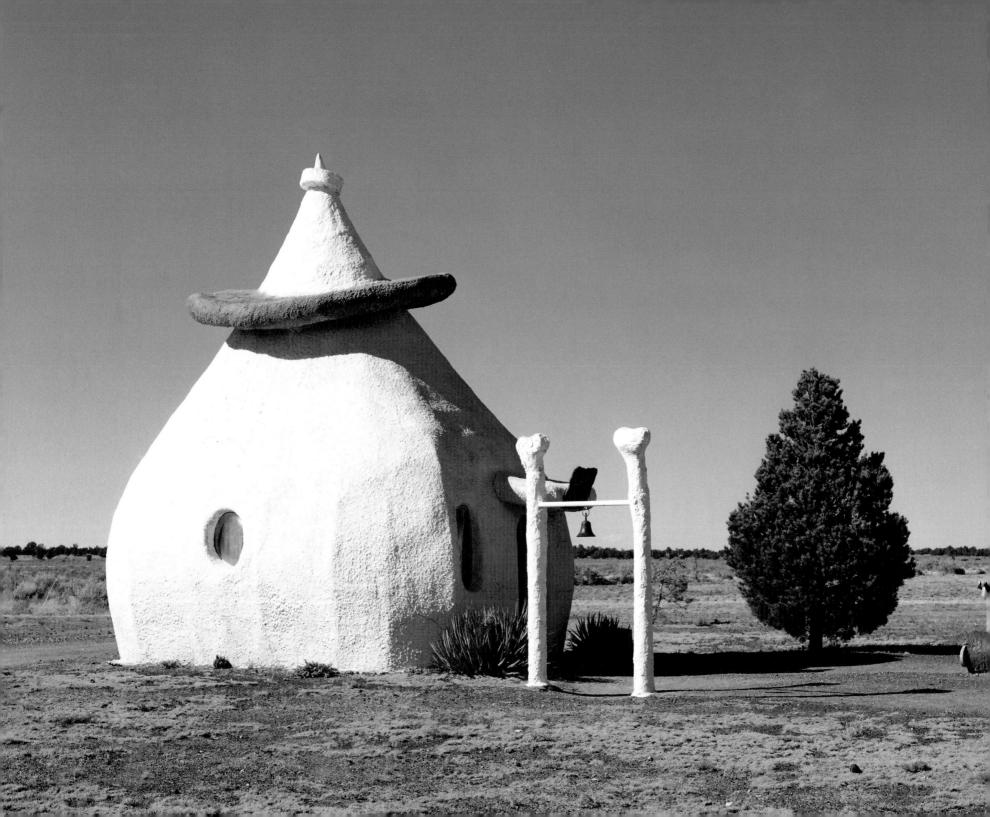

PLEASE MANGUP PHONE WHEN NOT IN USE!

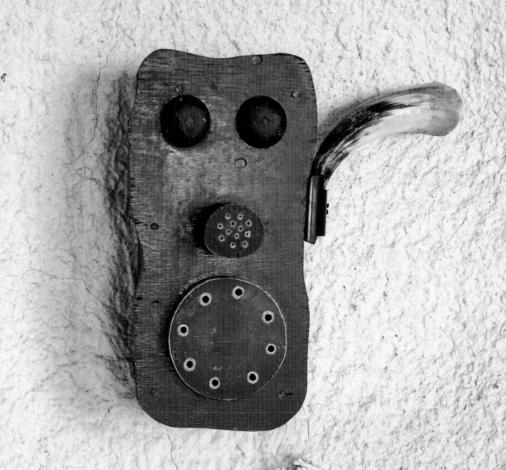

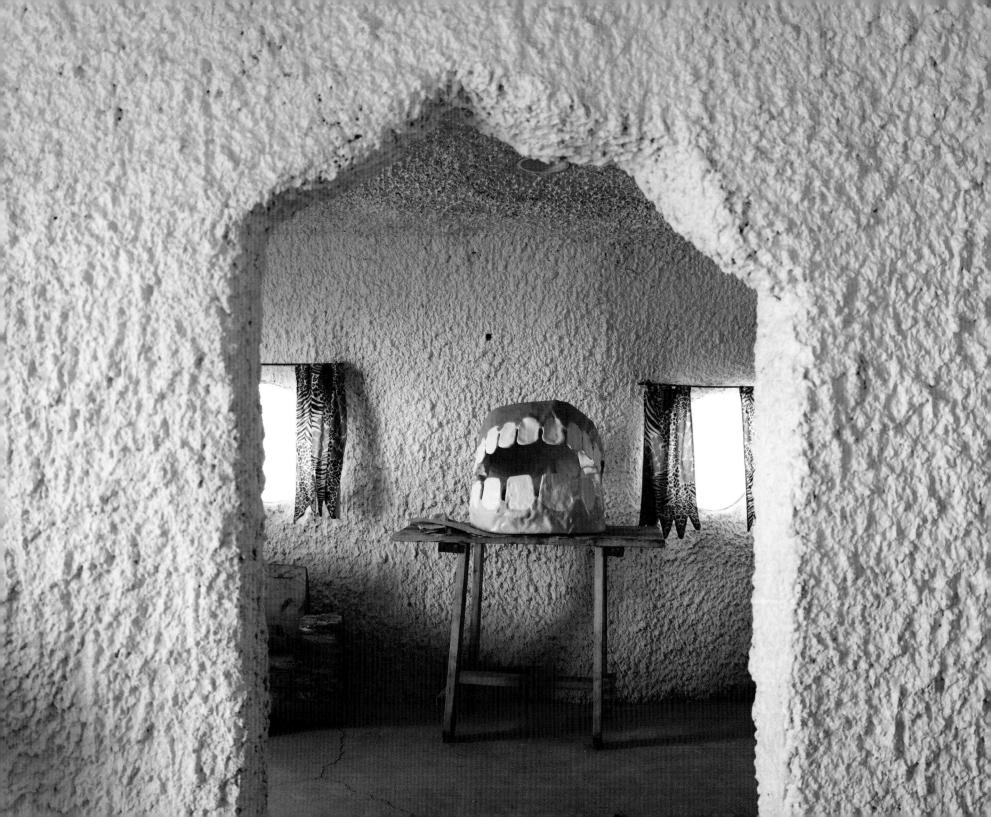

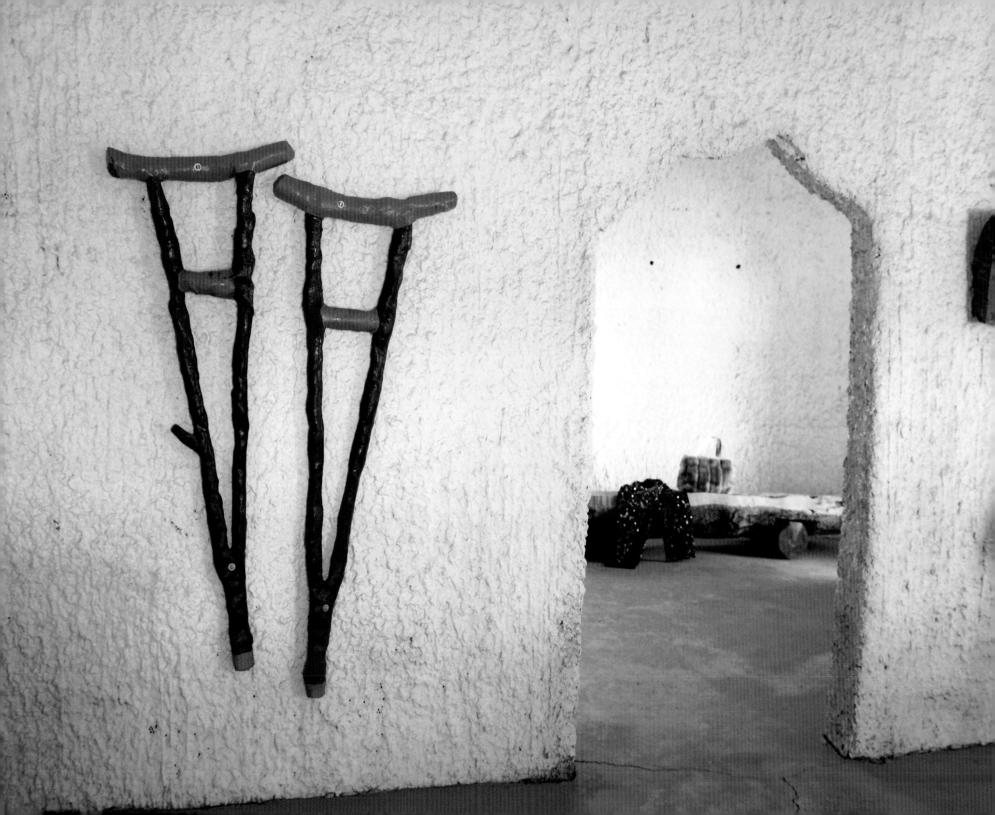

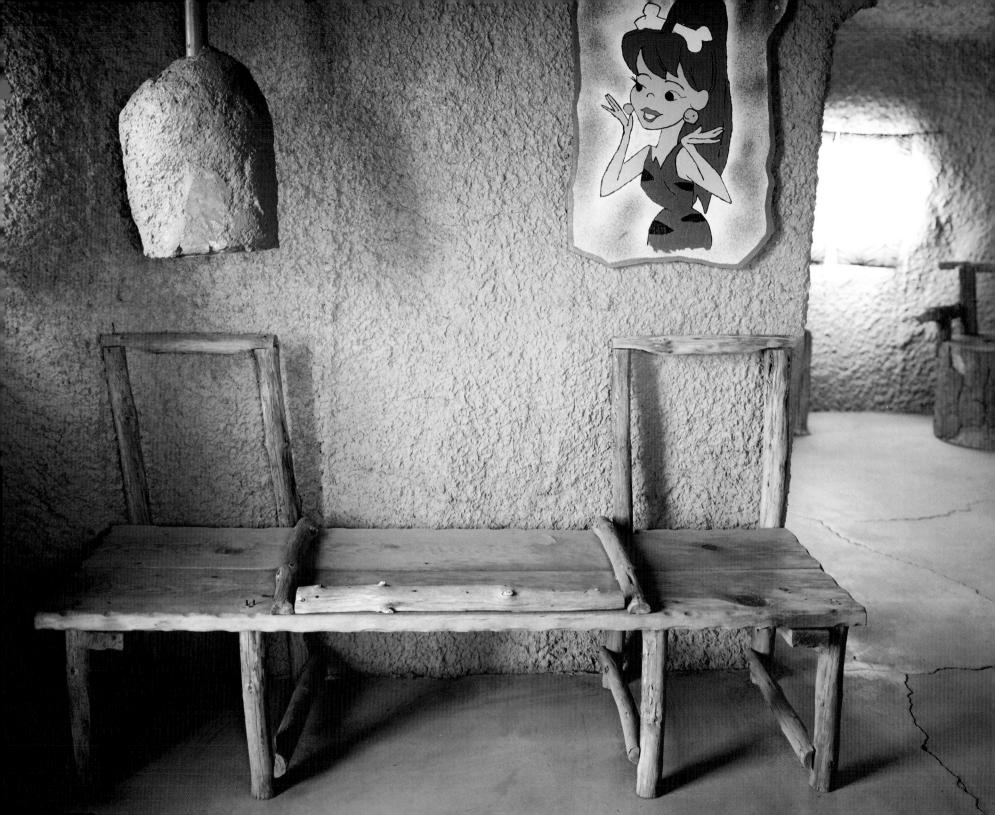

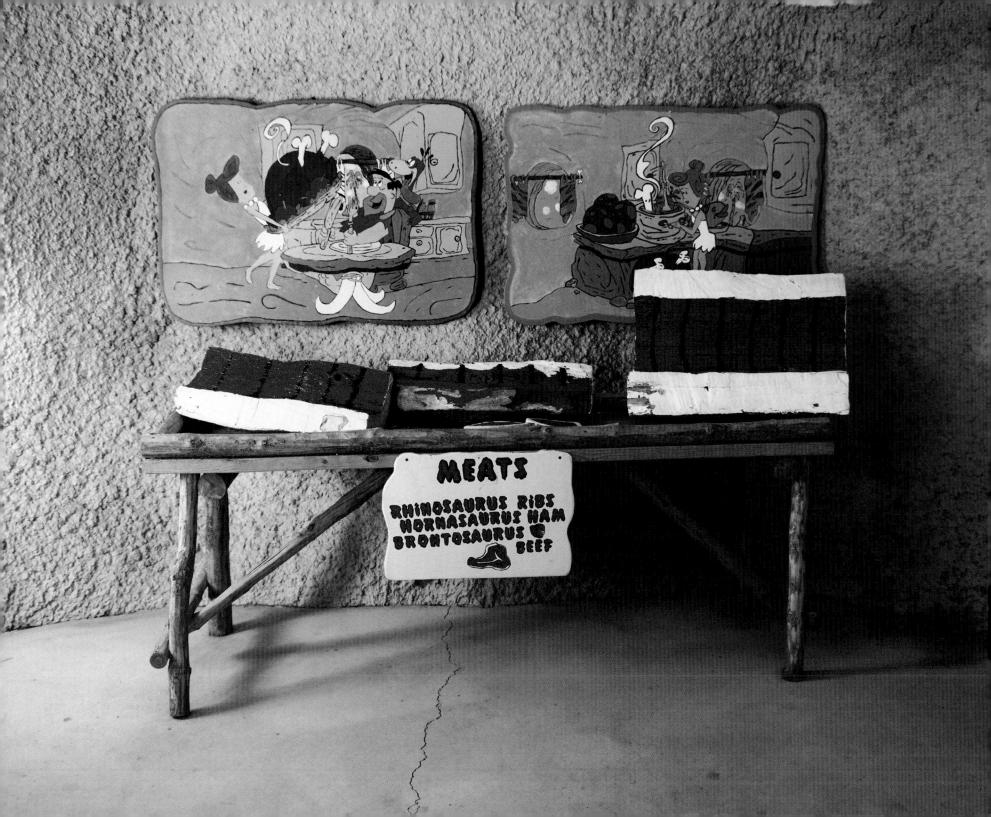

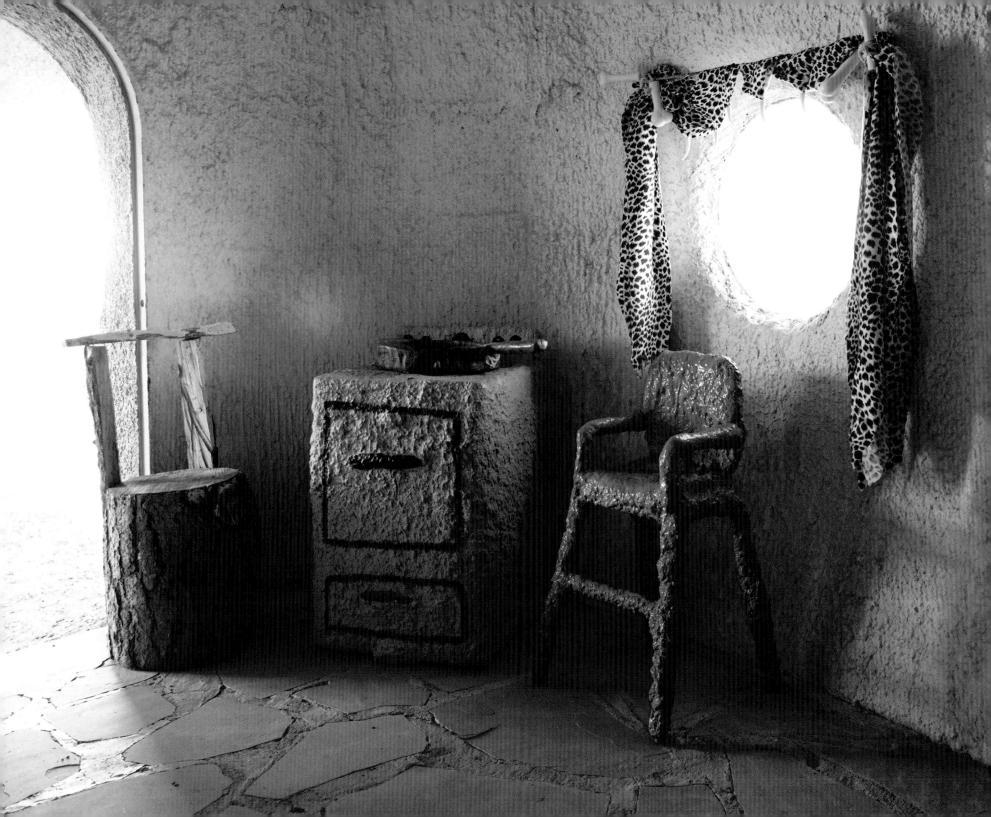

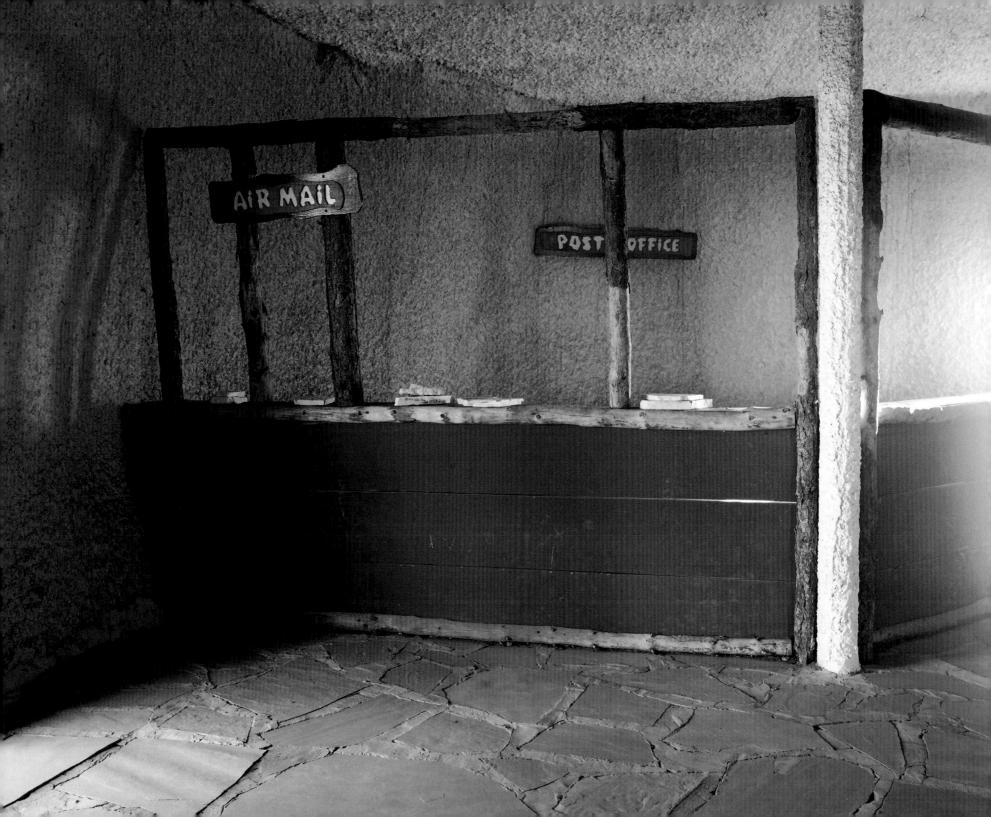

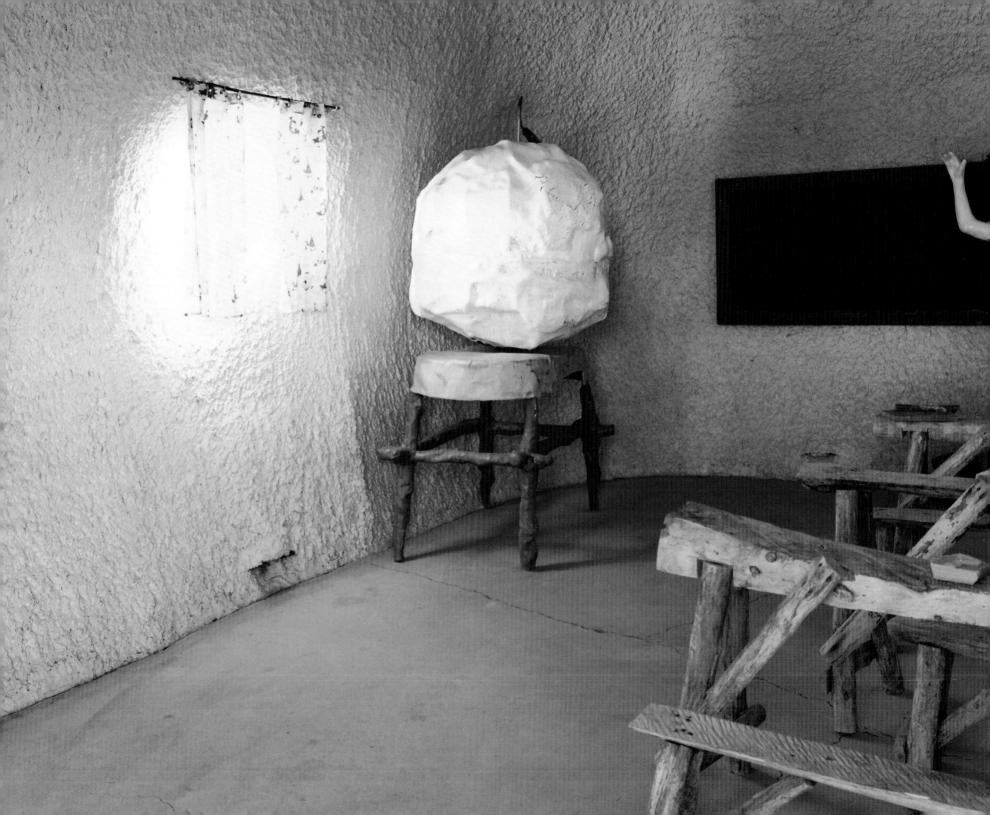

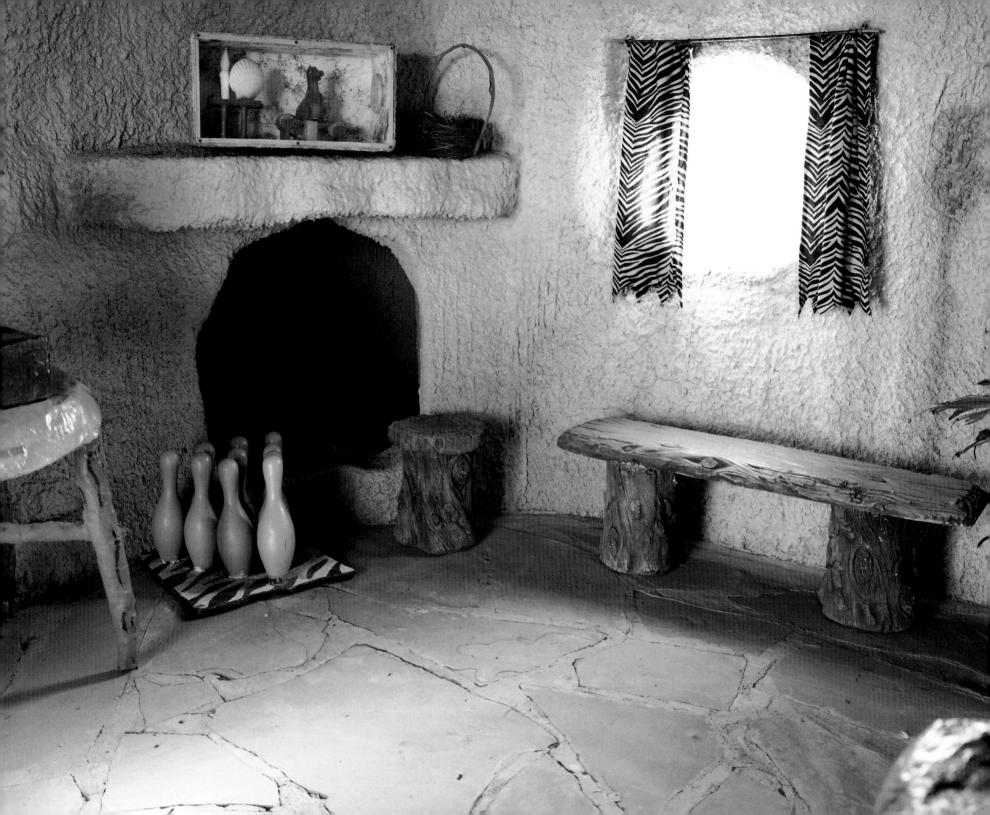

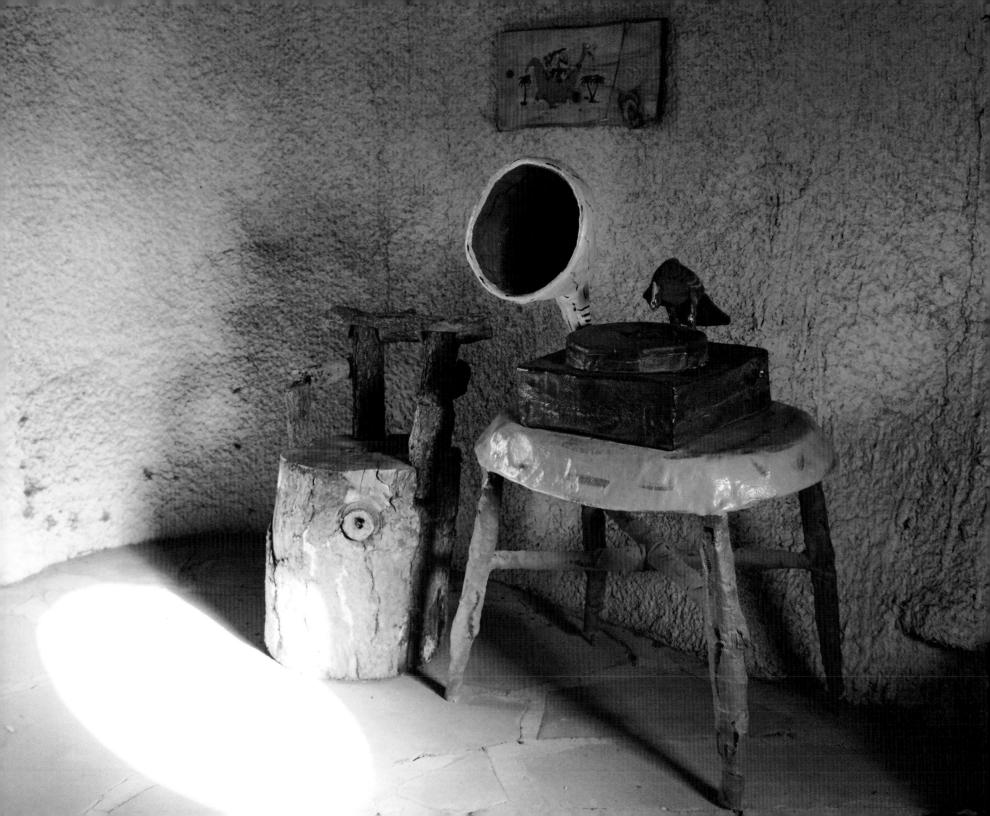

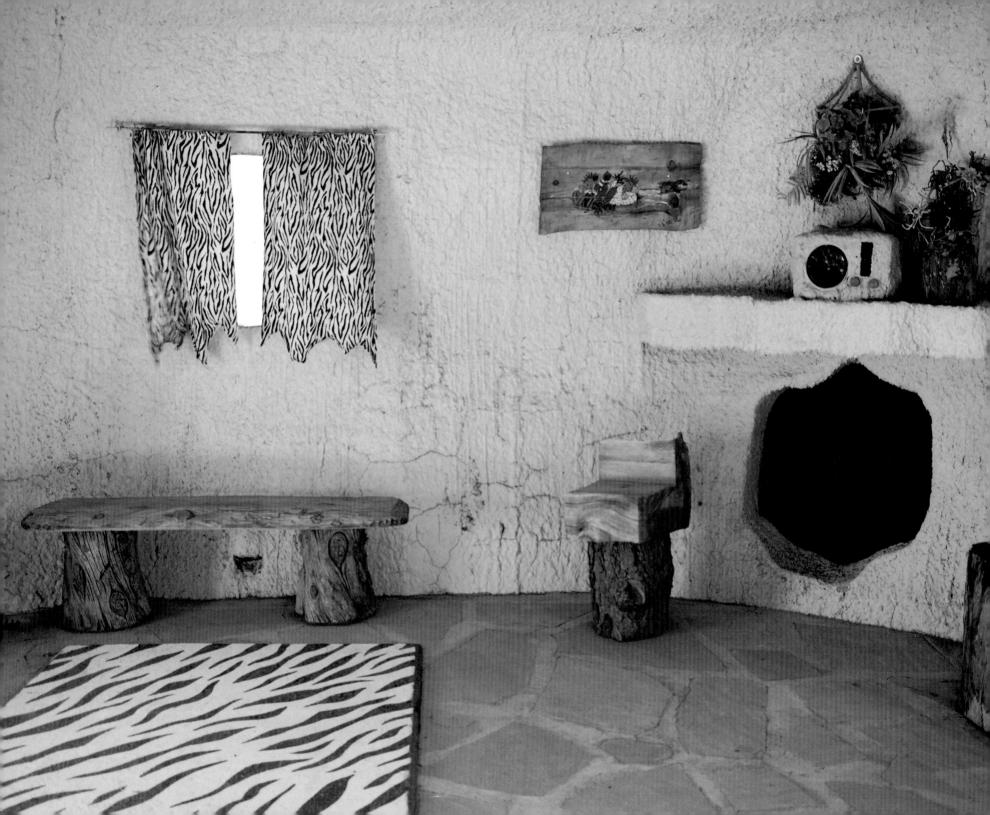

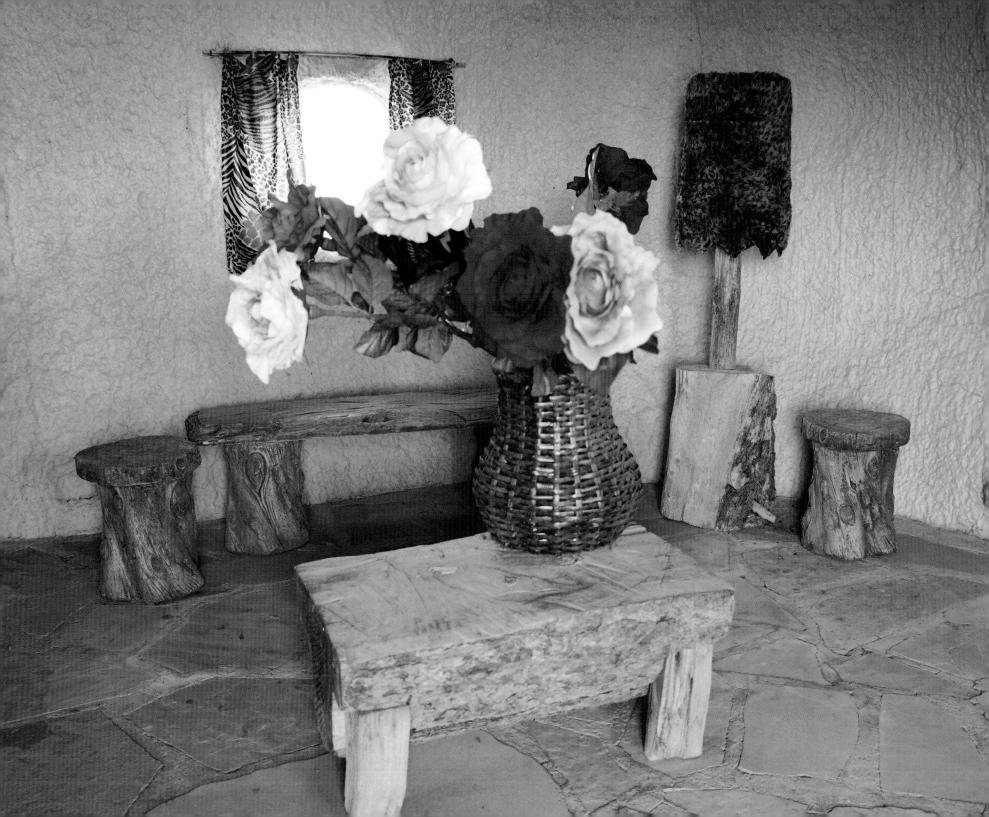